Blue Highways Revisited

University of Missouri Press Columbia and London

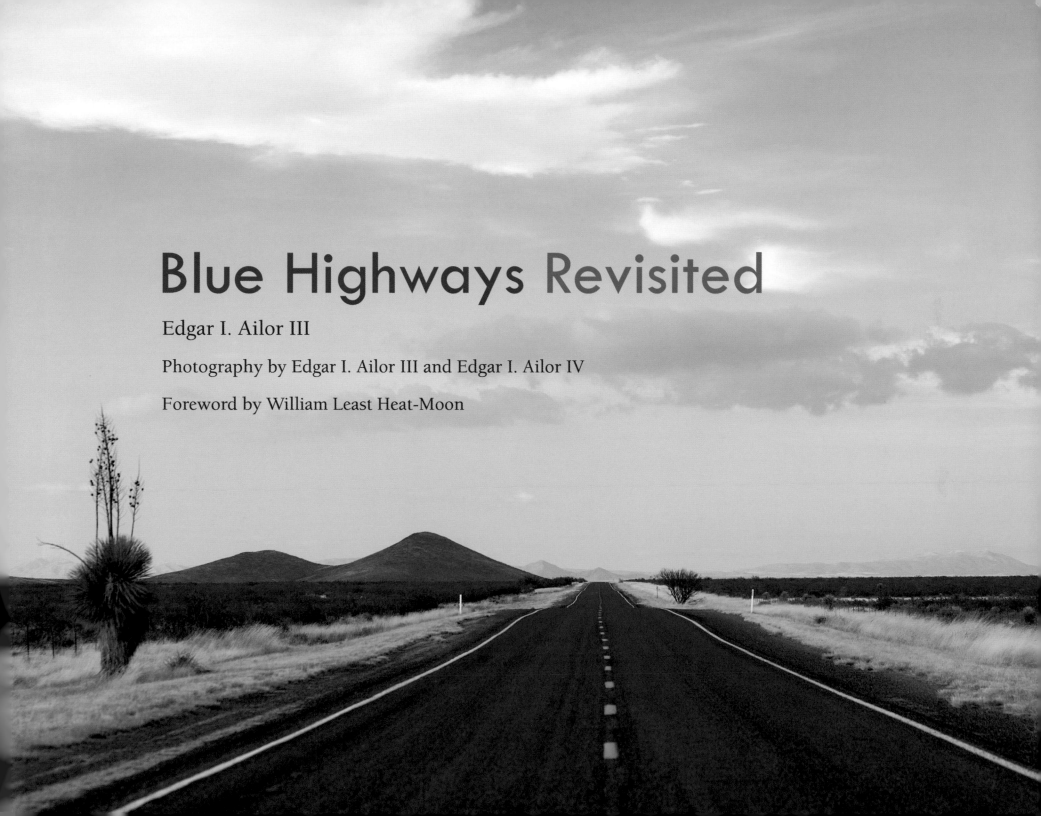

Blue Highways Revisited

Edgar I. Ailor III

Photography by Edgar I. Ailor III and Edgar I. Ailor IV

Foreword by William Least Heat-Moon

Cataloging-in-Publication data available from the Library of Congress.
ISBN 978-0-8262-1969-5

∞™ This paper meets the requirements of the
American National Standard for Permanence of Paper
for Printed Library Materials, Z39.48, 1984.

Design and composition: Jennifer Cropp
Printing and binding: Regent Publishing Services Limited
Typefaces: Minion, Twentieth Century, and Berkeley

Uncredited images: p. xiv, Dirt road off Arizona Route 186;
p. 316, Ewell Harbor, Smith Island

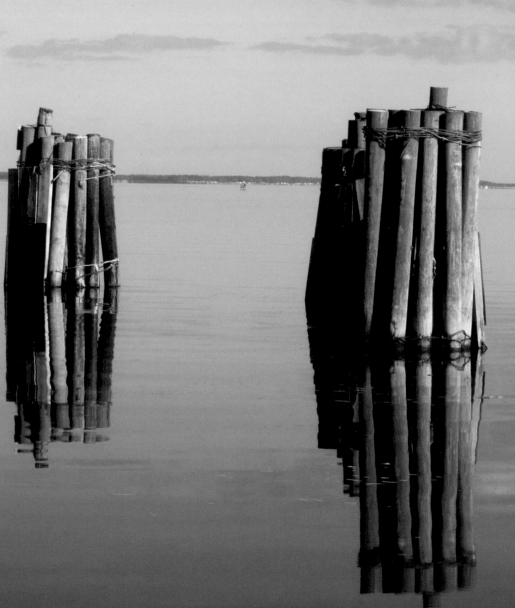

To all those who

have inspired me

throughout my life,

and to Susie, the

most inspiring of all

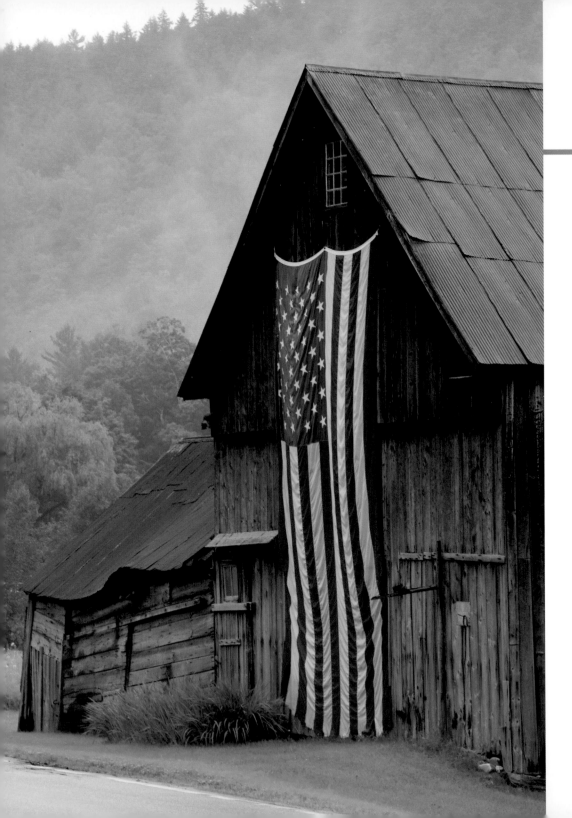

Contents

Old US 95 winding up Lewiston Hill, Idaho

Foreword

Readers of *Blue Highways* often ask whether I will ever repeat my 1978 trip—to see how America has changed—and I explain, to their disappointment, I have no plans for ever redoing the journey. So, when Ed Ailor told me some years ago he and his son, Edgar IV, wanted to retrace my journey and make a book of photographs of the route, I was pleased but skeptical. I thought it unlikely anyone would have the dedication to undergo those almost fourteen thousand miles. (In fact, their mileage surpassed mine.)

I have worked with Ed to review both the images he and his son have made, as I also have Ed's text, and I give assurance his facts and details about my trip over the blue highways are correct. The photographs, often with remarkable accuracy, capture my verbal images and the spirit of the book. Taking the journey again through these pictures, I have been intrigued and even somewhat reassured that America is changing not quite so destructively as often it can seem. The Blue Highways *Revisited* photographs, happily, reveal a recognizable continuity (but for how much longer who can say?), and I'm glad the Ailors have recorded so much of *Blue Highways* while many of the people and places are yet with us.

Their diligence in searching out numerous locations I wrote about—from streetscapes to Bert and Betty eateries to details of the wayside—is noteworthy, and with each passing year it's a feat less likely to be done again so amply. I was surprised and delighted Ed found eleven of the individuals I spoke with still alive and willing to comment on how *Blue Highways* affected their lives. Because the people in my book have always been at the center of readers' curiosity, Ed's portraits, side by side with my earlier ones, are revealing and touching and will be one of the most interesting aspects of Blue Highways *Revisited*. I asked him to make digital scans of my negatives so that the original quality of my portraits done on film can once again be revealed; the muddied reproductions appearing in the many reprints of *Blue Highways* have been rectified here and can at last be seen as they were in the beginning.

Ed and I talked often about both my trip and the writing of *Blue Highways* so that his *Revisited* contains significant information never before published, details I believe readers today will find pertinent and sometimes amusing. His reportage is accurate, and it corrects a few fouled assumptions that have circulated for some time.

I have hope that the Ailors' artful *Revisited* images will bring *Blue Highways* to an audience of both those who knew it when it was fresh off the press and those who will discover it for the first time.

—William Least Heat-Moon
October 2011

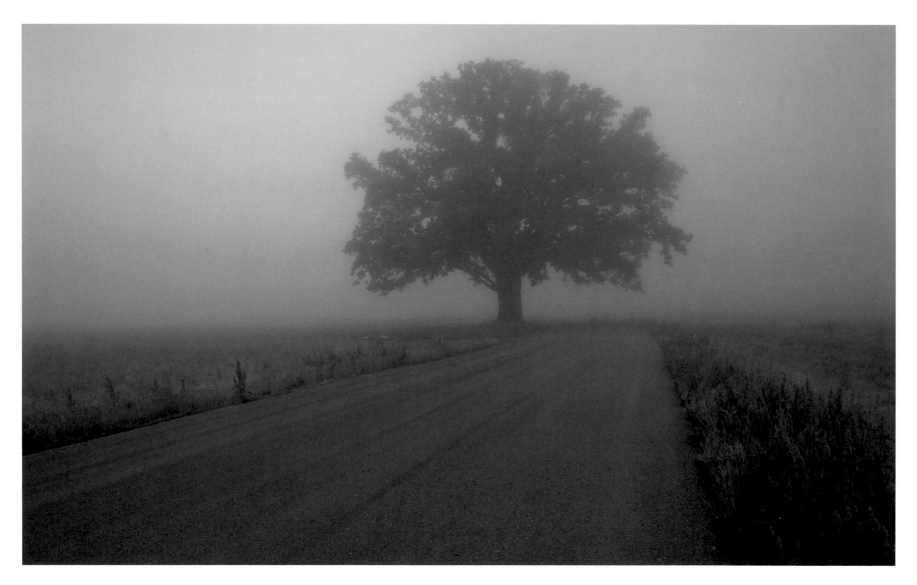

"A mysterious cast of blue."

Pre-dawn image of a 350-year-old Burr Oak located in the Missouri River bottoms near McBaine, Missouri—a few miles from where William Least Heat-Moon began and ended his journey. This image reveals how in "times neither day nor night—the old roads return to the sky some of its color" (*BH* Introduction).

On the old highway maps of America, the main routes were red and the back roads blue. Now even the colors are changing. But in those brevities just before dawn and a little after dusk—times neither day nor night—the old roads return to the sky some of its color. Then, in truth, they carry a mysterious cast of blue, and it's that time when the pull of the blue highway is strongest, when the open road is beckoning, a strangeness, a place where a man can lose himself.

—Introduction to *Blue Highways*

They say a picture is worth a thousand words, but sometimes it is the dialogue that defines the picture frame. As Heat-Moon says: "the traveler who misses the journey misses about all he's going to get." If we cannot visualize the territory of *Blue Highways*, then we miss an important part of the journey. While the roads evoke images, the combination of pictures and words gives a texture to the landscape and a snapshot of the soul.

Our goal in revisiting *Blue Highways* some thirty years after William Least Heat-Moon's unforgettable journey in 1978 was to capture the images he describes: the awe-inspiring diversity and beauty of back-roads America, its colorful cafes and the five-thirty taverns, and the remarkable people he met. With Heat-Moon's eloquent, graphic, and exacting descriptions of landscapes and terrain to read, we found driving along the same highways often resulted in a vivid sense of déjà vu. Time after time, a scene from the book came into focus around a bend or over a hill. We stepped off the pages of the book to recapture an experience recorded thirty years prior.

The three- and four-calendar local cafes, corner taverns, and the wise and entertaining characters Heat-Moon met along the way were a greater challenge to find three decades later, but we were able to track down eleven of the individuals still living. What was most consistent throughout his 13,889-mile journey was the overwhelming and individual beauty of the people and the back roads of the thirty-eight states and the hundreds of small towns that *Blue Highways* encounters.

While we can update you three decades later about many of the people and places of *Blue Highways*, we can't reinvent the wit, humor, and storytelling Heat-Moon brings to the page. So why don't you pick up your old copy of *Blue Highways* or if your friend never returned it, get a new copy—it's still in print. The page numbers cited throughout this book with the abbreviation *BH* refer to the original book, so you can easily locate a passage and compare Heat-Moon's verbal imagery with our photographs taken some thirty years later. The page numbers correspond to Little, Brown and Company's 1982 first edition and also to the Back Bay first paperback edition of 1999.

We occasionally veer away from the *Blue Highways* path for a few miles, but we'll always let you know when we do. You might also note that the image we captured may not always match the season Heat-Moon describes. His trip was undertaken during three months of continuous travel, lasting eighty-two days, from the first day of spring to about the first day of summer. Coincidentally, we spent eighty-two days photographing his route, plus twenty-six days of additional travel getting home and back to where we last photographed. We broke up the trip into thirteen segments, which ranged from two to twenty-nine days, and the season from spring through fall over several years. Breaking it up made the route no less spectacular or impressive—quite the contrary. It gave us an appreciation of what William Least Heat-Moon accomplished in one continuous trip.

Heat-Moon has allowed us to photograph pages from his original logbook written on the journey as well as several early manuscript pages, his Olympia typewriter used to write the first several drafts, Ghost Dancing, and more. Discussions with him about these archival images add insight into the travels and the writing of *Blue Highways* that only the perspective of the author could provide.

So now, please take a seat and travel with us to "a place where a man can lose himself"—find himself as well.

—Edgar I. Ailor III and Edgar I. Ailor IV

Acknowledgments

Throughout My Life

So fortunate I was—blessed is the best way to put it—that I was born to two hardworking, loving, nurturing parents, Edgar I. Jr. and Kathleen Ailor, both educators. As far back as I can remember, it was a foregone conclusion that I would go to college—probably beyond. I was nestled among a wonderful big sister who teased me just enough and led me through the path of adolescence, an adorable little brother who kept me laughing and entertained, and two supportive parents. I couldn't have grown up in a more encouraging environment.

At Southeast Missouri State University, I was fortunate to be exposed to the exhilarating teaching of Dr. John Hinni for embryology and to have his sage advice as my pre-med advisor. Dr. Don Froemsdorf and Dr. William Haynes made chemistry entertaining and exciting. In medical school the inspirational teachers may be TNTC (too numerous to count), but Drs. Hugh Stephenson, Ford Keitzer, and John Lukens stand out. In my residency training Drs. Marion DeWeese, Don Joseph, William Davis, Jerry Templer, Richard Holt, and Regan Thomas all deserve a pedestal—all outstanding teachers and physicians.

However, it was just outside the door to Dr. Haynes' office at SEMO in the spring semester of 1967 that I met the person most inspirational in my life—a memory indelibly recorded by the hippocampus of my brain. Squatting in front of the door to see a posting positioned about three feet off the floor, I had just found my score for a quantitative analysis exam. I turned to see an angel perched on a table wearing a rather short suede skirt—lovely legs crossed and adorned with net hose. When I forced my eyes to a higher level, I found a beautiful face, warm blue eyes, and a heart-dissolving smile. She was patiently waiting to check on the results of her qualitative analysis exam posted on the same door. In retrospect, I can't remember what I said to her. It was pure chemistry at first sight. I was lucky to marry that chemistry major on June 7, 1969.

To this day, just seeing her and her disarming smile gives me that same excitement and delight—she is my sunshine by day, and she lends light to the stars and moon by night. Thank you, Susie, for your enveloping love, your infectious positive spirit, and your energy that irradiates the life of anyone lucky enough to be around you. You inspire all of us to aim for higher goals, and your contagious enthusiasm makes attaining them plausible. This book is dedicated to you.

For This Project

It was Heat-Moon's *Blue Highways* that destined father and son to be lured to the open road. To follow his path and to find people and places still bathed in that "mysterious cast of blue" was a remarkable journey for us. First with his book and then with his unwavering support of this project, Heat-Moon has been a never-ending source of energy and dedication. His editing was tough and relentless. We give our thanks for his commitment and friendship. We are very appreciative of Little, Brown and Company and of Heat-Moon for granting us permission to use quotations from *Blue Highways* throughout this book and allowing us to use the map of Heat-Moon's route and original photographs of the characters from *Blue Highways* on pages 20, 26, 36, 58, 94, 120, 130, 162, 174, 210, 240, 250, and 284 of Blue Highways *Revisited.*

Without Heat-Moon's words and his original portraitures, our photography would be significantly less meaningful.

Dr. Nan Erickson and Dr. Jill Barr, dear family friends, were tireless and meticulous in their proofreading, yet always encouraging. We are thankful for Clair Willcox, editor-in-chief, for his support and belief in the project; Sara Davis, managing editor, for her extraordinary effort and vision in getting our book into its final form; and Pippa Letsky, editor, for her fresh eyes and thoughts.

We are thankful for the support and encouragement of our families throughout this project: Angie, Ben, Hannah, Jacob, Brendan, and Nannie. Most of all we are grateful to both our wives, Susie and Melissa, for their understanding of the time dedicated to this project. Their love and support made this book possible.

Blue Highways Revisited

THE ROUTE

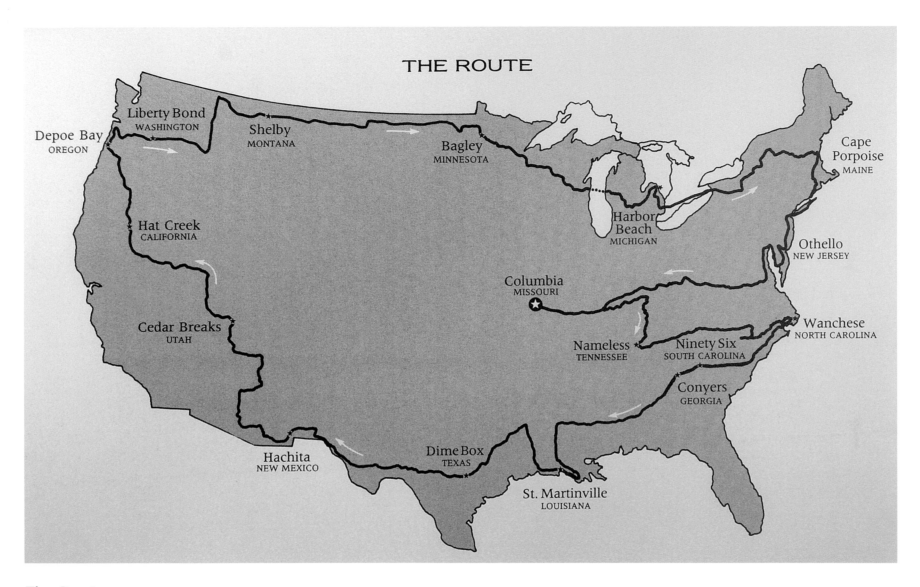

The Route.

Drawing by G. W. Ward that appears in *Blue Highways*, courtesy of William Least Heat-Moon and Little, Brown and Company (*BH* 413). The almost fourteen-thousand-mile journey began in Columbia, Missouri, and moved clockwise around America.

The Seed Was Planted Early

My wife, Susie, purchased our hardback copy of *Blue Highways* the first week it hit the bookstores. I read the first few chapters on a winter evening in January 1983, and I was hooked. I proceeded to read much too late that night, and the alarm went off early the next morning. The thought of getting into a van and traveling the less-traveled roads of America—"the don't-blink-or-you'll-miss-it towns"—captured my imagination. I remember thinking, "Someday I'll make the trip . . . someday." In January 1983, however, Susie and I were enjoying my otolaryngology practice and our two children—Angie, aged eight, and Gar (Edgar IV), aged five. Susie was in her second year of medical school. To travel fourteen thousand miles in a van on the back roads of America would have to remain a dream—for almost three decades.

One day Susie told me, "The author of this book sits just two seats from us at Hearnes [home of the Mizzou Basketball Tigers in 1983]. You have to get it autographed!" Our paths continued to cross, and our friendship grew. When Susie and I moved to a rural area southwest of Columbia, we lived only a couple of miles from Heat-Moon. We all shared a love of the solitude, the beauty of the rolling forested hills, and the abundant wildlife. I would occasionally see Heat-Moon as his physician.

Susie, knowing my dream to pursue landscape photography as a second profession, encouraged me to retire a few years early—"while I was still young enough" to climb mountains and hike streams. She also found advertised in *Outdoor Photography* a Sportsmobile, a Ford F-350 converted to a small four-wheel-drive RV, the vehicle I would use to travel

Indiana Route 62 east of Sulphur.

the *Blue Highways* route. She knew of my hope to photograph the places along the way; and as my most persistent supporter, she told me to "go for it!" Over lunch in downtown Columbia, I pitched the idea of revisiting the route, photographically, to Heat-Moon. I showed him some photographs of the Oregon coast, part of his northwest route. He told me that one of the most common questions he receives from his readers is "When are you going to take the trip again to see how things have changed?" So he liked the idea, even though he thought it unlikely anyone, including me, would follow through with retracing the full route and set it into book form.

In spite of Susie's support, I knew I couldn't be gone for three consecutive months. I began with the first of thirteen trips on October 1, 2006, and completed the last large section—North Dakota to the east coast and back to Missouri—on August 5, 2008. We later made several other, shorter trips to track down "characters" from the book. I was working hard between trips to keep my small photography business afloat, which consists of capturing landscapes to create a warm, inviting atmosphere in hospitals, banks, and a variety of businesses, with wall hangings ranging in size from twelve by eighteen inches to panoramas measuring ten by thirty-four feet. Having a son who was working professionally in photography by that time helped a lot. Gar was able to photograph states near where he was living that had portions of the *Blue Highways* route—North Carolina and New York. His contributions were limited by the necessity to continue his regular full-time employment. Getting to work with him was for me one of the most enjoyable aspects of the project.

Driving the route in the Sportsmobile was probably similar to traveling in Heat-Moon's Ford van, but my van had a few amenities his didn't. The top pops up—so when I'm stopped I can stand upright. It has air conditioning, a built-in generator, a microwave, a refrigerator, a propane heater, running hot and cold water with a shower off the back, a rear seat that folds down to make a full-size bed, a sound system, a DVD player, and a small flat-screen TV. Heat-Moon had a radio, a cooler, and an endless supply of freezing cold streams for bathing. He had a road atlas with him and purchased books as he traveled. I was well stocked with gazetteers. I would leave town with the refrigerator filled with one-person packaged portions from two of my favorite restaurants, although I also ate peanut butter and jelly as did Heat-Moon. He frequently parked on a street overnight. I usually looked for a county, state, forest service, or national park campground, or a shopping center parking lot when no park was nearby. I never got used to the street sweeper that cleans the massive parking lots sometime between two and five A.M.

As Gar and I photographed more and more of the route, Heat-Moon began to realize we were serious. In spite of his deadlines for his new book, *Roads to Quoz*, he took time to look at our images and make suggestions, contribute archival information and negatives of his original photographs, and provide insight about his trip. He even read and edited our text.

Striking Out

How does an individual decide to strike out on a long circular trip on the back roads of the United States, through thirty-eight states, leading to towns like Nameless, Tennessee; Dime Box, Texas; Frenchman, Nevada; and Cape Porpoise, Maine? Perhaps it is an ingrained sense of wanderlust—Heat-Moon's is strong. Home had become intolerable. Separated from his wife for nine months, he got word that she had found a "friend." With enrollment down, his teaching position had been eliminated at Stephens College in Columbia, Missouri. It seemed an opportune moment to hit the road, to satisfy a longing found in so many Americans.

On March 20, 1978, with $26 in his wallet, $428 hidden under the dashboard of his green Ford Econoline van named Ghost Dancing, a small gray spider crawling the dash, and four gasoline-company credit cards, Heat-Moon headed east on Interstate 70. Of course, I-70 is not a blue highway, but it led him quickly to new territory. He hit the first back road as he turned south on Illinois 4 just east of St. Louis.

So why didn't he go west? Heat-Moon told me, "I was following spring. I wanted to get to warm weather. The journey began after a bitterly cold winter when we set record lows all over the country." He would follow spring into the southeast United States, and by the time he reached the Northwest the cold weather would be gone. "I didn't want to sleep in a hot truck in Georgia or an icy one in Montana." He also noted that "no fellow with some Osage in him would go counterclockwise—*clockwise* is the sacred direction."

He refitted the interior of Ghost Dancing to suit his plans. "When I bought the van, it was an empty metal box. I put carpet down, installed paneling and a ceiling—all of it insulated. A friend helped put a roof port in." The bed was a wooden platform. "I had a thick foam pad from the medical school to put under a pair of sleeping bags. I slept crosswise to the van and kept supplies under the bunk. I loved being in there. On the *Blue Highways* trip, some mornings I'd wake up—when I wasn't too depressed about what was happening to me—I'd lie there and think, 'I can't believe I'm really doing this.'" We experienced the same elation while retracing Heat-Moon's route.

The cost of the brand-new van was $3,647. "I spent 187 nights in the back. If you figure a modest motel room then cost about $20, it comes out to $3,740. I considered the van was practically free—I paid just for lodging. Of the eighty-two nights on the *Blue Highways* trip, I paid for a room on only three nights." He stayed in a motel in Deming, New Mexico (*BH* 154), a hotel in Rolla, North Dakota (*BH* 274), and a tourist home in Woodstock, Vermont (*BH* 325).

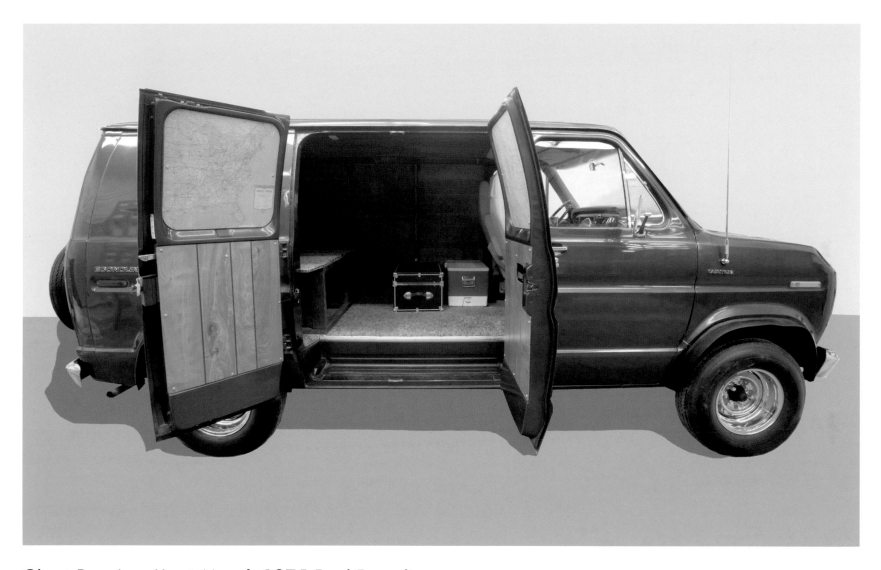

Ghost Dancing, Heat-Moon's 1975 Ford Econoline van.

"If you look at the photograph of the van with the doors open, you'll see two maps of the United States I put on the inside of the doors. I wanted the effect of a window. I wish now I had marked out the *Blue Highways* route on those maps; but, of course, I used this van for many other trips." His "wheel estate," as one mechanic called it (*BH* 8), is now housed in the Museum of Art and Archaeology Support Center on the University of Missouri campus in Columbia.

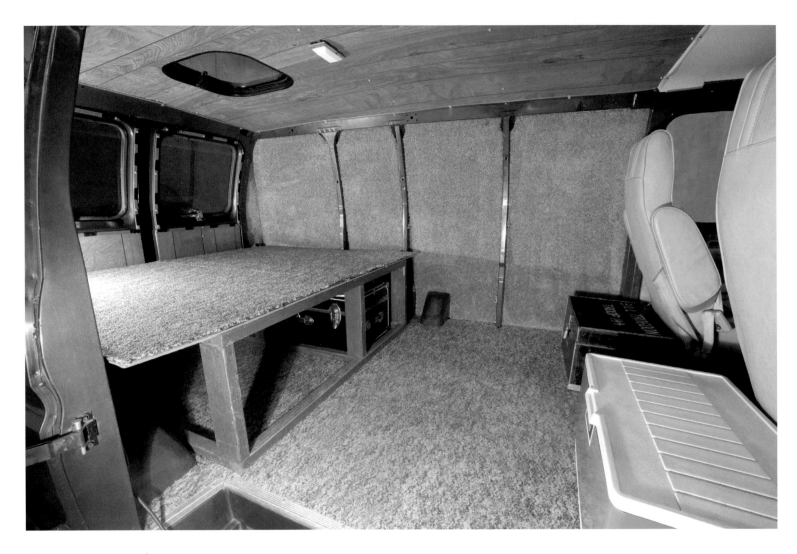

Ghost Dancing's interior.

Heat-Moon slept on the raised platform in the rear of the van.
The two trunks and the cooler held his supplies on the trip.

	FORD	JOE MACHENS FORD, INC.
Torino Maverick Pinto		1911 W. Worley Phone 445-4411
		COLUMBIA, MISSOURI 65201

DATE	SOLD TO: ADDRESS	INVOICE NO.
April 16, 1975	William L. Trogdon 811 College Park Columbia, MO 65201	8338

CUST. NO.	STOCK NO.	YEAR-MAKE	MODEL	NEW OR USED	SERIAL NO.	KEY NO.	SALESMAN
	1459	75 Ford	Cargo Van Econoline	new	E04BHW70844	FA 1674	Payne

INSURANCE COVERAGE INCLUDES

☐ FIRE AND THEFT ☐ PUBLIC LIABILITY- AMT.

☐ COLLISION - AMT. DEDUCT. ☐ PROPERTY DAMAGE - AMT.

OPTIONAL EQUIPMENT AND ACCESSORIES

GROUP	DESCRIPTION	PRICE

I have received title application, C. O. and
odometer certification--mileage _____

PRICE OF CAR	3647.00
FREIGHT AND HANDLING	
OPTIONAL EQUIP. & ACCESS.	
SALES TAX	
LICENSE AND TITLE	
TOTAL CASH PRICE	3647.00
FINANCING	
INSURANCE	
TOTAL TIME PRICE	
SETTLEMENT:	
DEPOSIT	100.00
CASH ON DELIVERY	3547.00
USED CAR:-	
TYPE	
SERIAL NO.	
ENGINE NO.	
PAYMENTS:	
TOTAL	3647.00

ALWAYS SHOW SERIAL, ENGINE AND KEY NUMBERS

83-4089 NORICK • OKLAHOMA CITY • LOS ANGELES • SAN FRANCISCO • CHICAGO • ATLANTA

Ghost Dancing's bill of sale.

Heat-Moon sold a four-cylinder Austin and applied that five hundred dollars to the cost of the van.

1

20 MARCH - DAY ONE MONDAY (VERNAL EQUINOX)
4:55: I-70 E FROM COLUMBIA, MO.
The Grand Journey. 29,900 MILEAGE
Overcast, some clouds, sky is golden
pink on all horizons. Darker clouds
above. No indication of whether heading E,W,N,S.
Clouds circled above.
 Leaving apt: Sound (high whistle) of
freight train to north. Lifted spirits -
the siren song of the long distance traveller.
Sparrow hawks in dead elm or - the
nestlings - were wheeing, unseen. By my
return, a season later, the nestlings
will be grown + gone. They will have
eaten their weight three times a day in
mice, bunnies, other hatching birds, insects.
Snow still pile on slopes - drifts - 3 ft.
high. Pockets of ice in protected, sunless
spots. A day with a foot in both seasons.
58° high humidity. People wearing coats
that are much too warm. Smell of perspiration.
Little farm ponds still frozen. An indication
of winter's hardness since temperatures have
been above freezing for a week or more.
 Desolation is not with me. It seemed
my comrade in arms on the road had tired
himself in the days before the departure.
But he must be waiting somewhere.
Herr Doktor Desolation.

The first page of the Blue Highways logbook.

These notes give an idea of how *Blue Highways* began. Heat-Moon "logged in" at the end of each day or on the following morning. Compare this page with *Blue Highways* (*BH* 4) to see how one became the other.

"The first draft of *Blue Highways* was the logbook I kept on the trip," he told me during one of our conversations. "I had a handwritten copy of basic material before I started writing the manuscript in pencil, then to ink, and then to the typewriter. I get blocked if I try to do a first draft with a machine rather than a pencil."

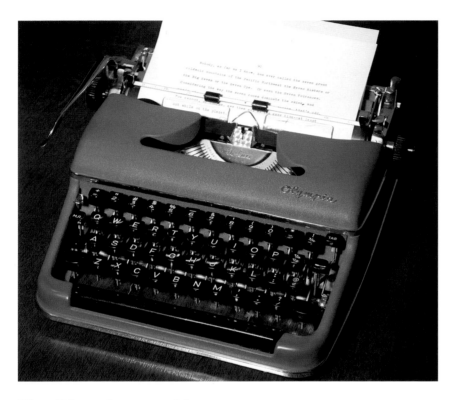

The Olympia portable.

This "solid little machine" was the typewriter Heat-Moon used for the first several drafts of *Blue Highways*. The sheet of paper in the machine is an actual page from an early manuscript.

Look at the crack in the right plastic paper guide (top center). Heat-Moon was working at the county courthouse as a clerk by day and writing his book at night. After ten months of that schedule, he was burned out. One night when the words weren't going well he had a kind of mental blackout. "I came to, and I had a flip-flop in my hand, and I was whacking the typewriter—trying to beat the proper words onto the page."

Blue Highways *manuscript,*
page 1, chapter 1 (BH 3).

This is an early draft. There were eight complete typed drafts. "Some individual pages I rewrote four to five times within a single draft," Heat-Moon said. "A page could frequently have thirty or forty changes. And the opening paragraph—it's only about a hundred words—I rewrote two dozen times."

~~BEGINNINGS~~

~~I~~

2

It was

the night before leaving. At 1:30 a. m. I was still awake. I lay in ~~bed~~ a tangled mess of sheets and blankets and wondered why I had concocted such a piece of madness. I wondered how it could ever be accomplished. In the morning I was to leave on a great circular trip *about* the United States that would be the equivalent of driving half-way around the world.

Then a strange sound interrupted my tossing--the honking of Canadian geese. Somewhere up in that March blackness, in that cold, thin air, a troop of geese was working its way north. I went to the window, feeling the cool air against my eyes. At first I saw ~~nothing~~ only starlight. Then they were there. A~~n~~ undulating U-shaped *configuration* ~~glowing strangely in the black,~~ honked across the *deep* sky, Their white bellies glow*ing* *strangely* with the reflected light from town.

How far had they flown? How much farther? And then I understood that I would accomplish my trip as they were theirs-- *by moving a little in the present moment,* ~~one yard at a time.~~ Without looking ahead.

1

Out of Lexington (the road winds ~~roundabout~~ like grapevine) The ~~wooden~~ straightest lines of the

fences meet~~ing~~ at right angles, the black creosoted barns next to the

white houses make the area look like a crossword puzzle. I

am enjoying the feel of the road as the van leans in and out of the

curves and drops over the rises in the road. A billboard

with an blood orange ~~sunrise~~ sun throwing out ~~pouring forth~~ radiant beams

(like the Japanese flag) and a cross ~~sitting on top of it~~ above the sun blocks the view.

Large imperious letters say THINK ABOUT IT. So I do. And

I decide that ~~the creator of~~ this ~~lovely~~ landscape, anyone who had a hand in making Kentucky would find

that garish sign, an abomination. ~~Here.~~ the gospel according to Sensual Wordliness advertising such a combination that But then it wouldn't

~~have~~ the Kentucky flavor of born-again religion, bourbon,

bluegrass, ~~Kentucky~~ burley, and thoroughbred breeders.

~~The pastures are~~ Small 19th century quarry ~~holes~~ cut dug into the holes/in little

limestone outcroppings water the ~~pasture~~ horses in the pastures.

Abruptly ~~the road~~ the road drops off the rolling plateau

of ~~pasture~~ pastureland and follows a ~~steep~~ deep wooded gorge ~~heavily~~

~~wooded~~ with precipitous sides that would make anyone proud down and down to the Kentucky River. Along the north

slope ~~the river~~ man-high columns of ice cling to the limestone,

safe in this cool and dark ~~gorge~~ chasm for a ~~couple of more weeks.~~ while longer. At the

bottom, the ~~highway~~ road heads straight for an abandoned highway

tunnel through a massive cliff then turns away and crosses

the river. This place they call the Palisades. It's a

beautiful, ~~place~~ and wholly unexpected, hidden as it is in

the ~~plateauland~~ gentle hills

Manuscript, page 33 (BH 18).

This early draft reveals the painstaking way Heat-Moon's writing develops. Compare this version with the final text on page 18 of *Blue Highways*. Notice the shift from present to past tense, a significant change.

```
            PROFILE ACKNOWLEDGMENT

     I have read the written presentation of my conversation
with William Trogdon, which is a portion of the book presently
titled Blue Highways, and I find it accurate in regard to me
and that it in no way disgraces or ridicules me or my work.

Date: _____

Signature: _____

Witnessed by: _____
```

For the Accuracy Check.

This is the form that accompanied the text of each individual's story Heat-Moon sent to the people who appear in *Blue Highways*. "In every book I've written, I do an accuracy check with the people who appear. I don't do it with somebody who's mentioned for a sentence or two, but for someone appearing at length, I send a copy of my text. They're free to make any kind of comments or corrections whatsoever. In some cases, I've sat at a kitchen table with them and read aloud what I've written."

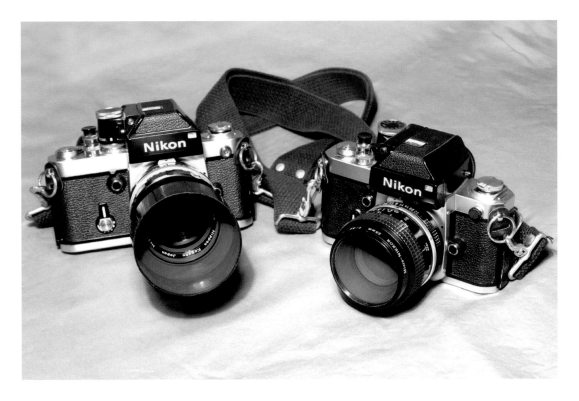

The two Nikon F-2 cameras Heat-Moon carried on his journey.

He used two lenses primarily—a 55 mm Nikkor macro lens (right), which he used for most of the environmental portraits, and a 105 mm lens (left). His aluminum case had a *Life* sticker by the handle. When he was fourteen that was his aspiration—to be a photographer for *Life* magazine.

"I wonder what *Blue Highways* would have been like if I'd had digital equipment and could have taken endless photographs without having to develop my negatives on the road. I was always hunting for a light-tight bathroom where I could process. I was afraid if I kept the film until I got home there might be deterioration of the images from heat or humidity.

"Once I returned home, I organized the negatives in a notebook—safe and protected. My partner at that time became upset one night because I was out late with the boys. She got mad and figured she needed to teach me a lesson. So she considered putting my negatives into the kitchen oven and giving them a toasting. Had she done that, I don't know what would have happened. I think the photographs helped the publishers believe in the book. They saw the pictures were an asset. But even more, I wanted to show readers the 'characters' were not fictional. I thought their faces were a testament. Had I lost those negatives, maybe *Blue Highways* would have been published and maybe it wouldn't—but it certainly would have changed the book."

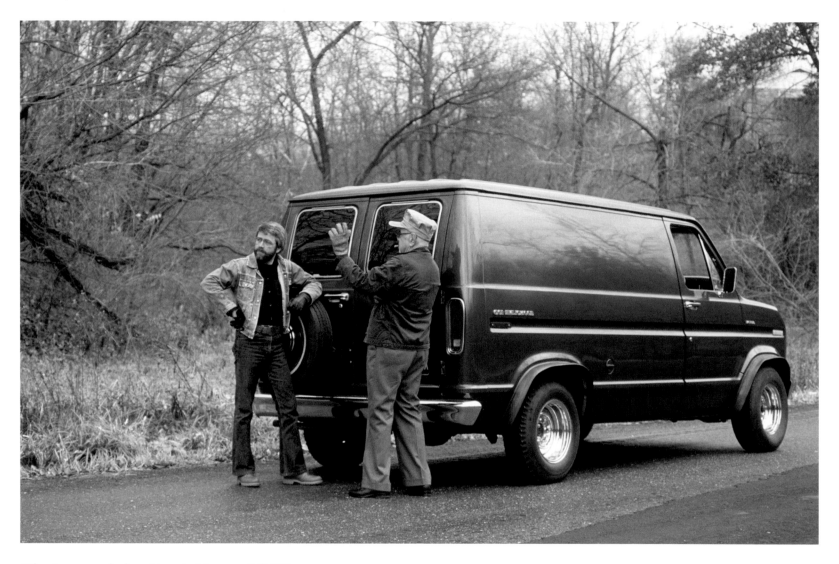

Photograph by Heat-Moon, 1983.

"This is an illustrative photograph—made after publication of *Blue Highways*—for an article in *Ford Times*. On that day, the only model available was my father. I put the camera on a tripod, set the self-timer, and ran back and forth to take several pictures. He's talking to me, waving his hand, pointing out something, much as people did occasionally on the *Blue Highways* trip."

Heat-Moon's Ancestry

I said to Heat-Moon, "We know from reading *Blue Highways* that you have Indian heritage, but in the book there isn't much detail about it."

He replied, "I don't consider myself an Indian, although it's part of my ancestry, which also includes English, Irish, Osage, and even a touch of German. Yet I don't call myself an Englishman or Irishman, so I'm not going to call myself an Indian; but that aspect of my background has been important to me. My Osage heritage—even though it was covered over for years—is important to me as a writer. In the last century any kind of Indian blood was frequently hidden away. I think that's somewhat changed today, but even years ago my father was proud to acknowledge all aspects of our family."

"Your dad's name was Heat-Moon, but yours is Least Heat-Moon."

"My elder brother is Little Heat-Moon. My father took the name Heat-Moon in the 1930s and used it exclusively in Boy Scouts. He was a scoutmaster and a member of the tribe of Mic-O-Say, a Scout organization in Kansas City, Missouri. The heart of the organization is in St. Clair County on the Osage River. The group draws upon the customs of the Osage.

When my father had to choose a name, he took Heat-Moon for several reasons. Because there were twelve adult leaders being brought into the tribe that summer, somebody thought to use the twelve names of the moon translated from Plains Indian lore. My father choose July—the moon of heat—because that, as far as we know, was the month of the birth of our last full-blood Osage ancestor. What the grandfather's name was in Osage I have never been able to learn. Indians were not citizens of the United States until 1924, so records give only his Anglo name. Years later when my elder brother came along and became a member of the tribe, he chose Little Heat-Moon. When I turned thirteen, I wanted to continue the family tradition, and that made me Least Heat-Moon. I had no idea at the time I would put it on a book. We didn't spell it with a hyphen because we rarely wrote the name. When *Blue Highways* first appeared, there was no hyphen and people began calling me Moon. That's half a name. I added the punctuation so librarians would know how to alphabetize the book and people wouldn't call me Mister Moon. On the early editions of *Blue Highways*, my Anglo name, William Trogdon, also appeared."

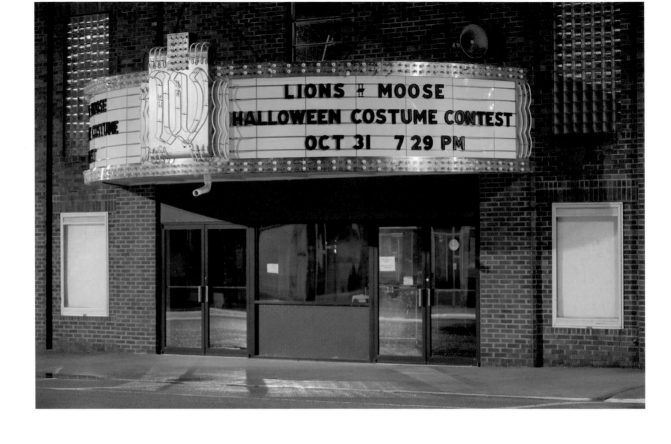

Historic Wabash Theater
marquee, Grayville, Illinois,
on Route 130.

I made this photograph in a drizzle on a cold November night. Although the marquee was not lit, the street lamps provided enough illumination for a time exposure. I was peering through my camera mounted on a tripod with my head and camera draped under a black garbage bag to keep the camera dry when a voice startled me.

"What are you taking a picture of?" Pat Seil, owner and editor of Grayville's paper, the *Navigator & Journal-Register*, had been working late and found me on Main Street at 11:40 P.M. I explained my mission. He told me, "Grayville folks puffed up with pride for a while from the mention of their town in a best seller. And for a few years people would follow the route and stop by Grayville, stirring up a little tourism as well." He went on to explain that the building was preserved and is maintained by people in town and serves as the site for four or five plays a year.

Heat-Moon spent the first night of his long journey next to this marquee. As he lay on his bunk, wondering what he had undertaken and whether he could complete such a journey, he "fought desolation and wrestled memories of the Indian wars." Because of Heat-Moon's Osage ancestry, and his wife's Cherokee heritage, he called their battles the "Indian wars" (*BH* 7). After the night in Grayville, he crossed the Wabash into Indiana.

Ohio River adjacent to Indiana Route 66, Mano Point Recreation Site near Derby, Indiana.

State Route 66 follows the muddy banks of the Ohio, "sometimes not ten feet from the road" (*BH* 9).

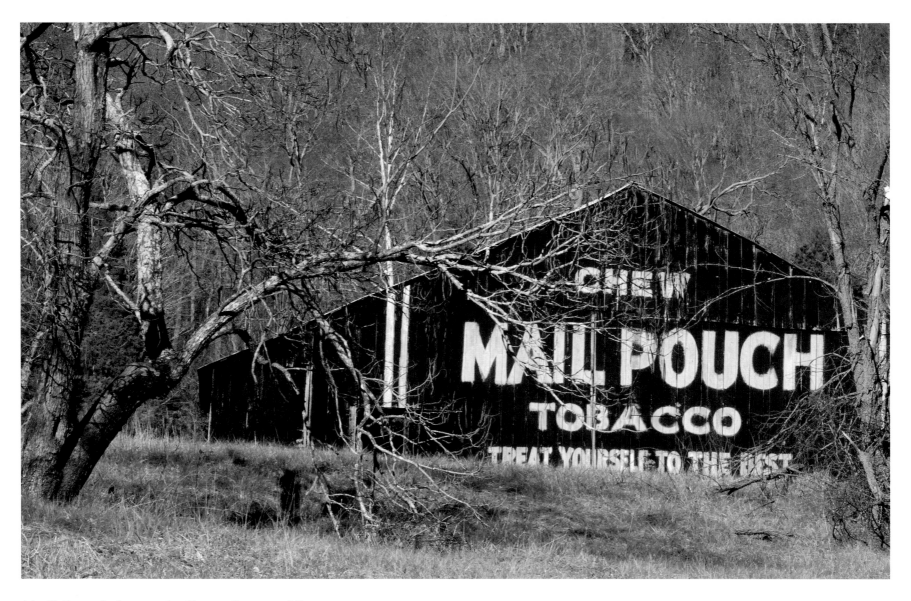

Mail Pouch barn, Indiana Route 62.

Indiana Highways 66 and 62 took Heat-Moon "into the hilly fields of Chew Mail
Pouch barns." The route was "so crooked it could run for the legislature" (*BH* 9).

William Tell "and his crossbow and nervous son," Tell City, Indiana, on State Route 66.

Heat-Moon followed 66 to Sulphur, then took Route 62 "through the old statehouse town of Corydon" and crossed the Ohio River into Kentucky at Louisville (*BH* 9).

La Grange, Kentucky, on Route 53.

Freight trains pass down Main Street more frequently than when Heat-Moon passed through (*BH* 10). The young man I spoke with at city hall said, "It seems more like twenty to thirty per day—I know a lot more than seven." I kept my ears tuned and my eyes glancing to the rear while taking this photograph.

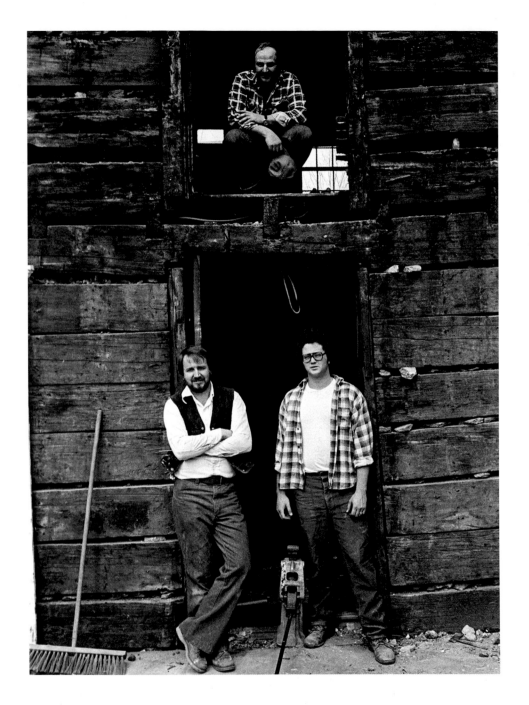

As Heat-Moon drove into Shelbyville, he found three men taking the siding off an old two-story house in order to expose the log cabin hidden beneath. Bob Andriot was restoring the building to use as a picture-frame and interior-design shop (*BH* 11–14). He stands on the left. The photograph on the opposite page is Andriot twenty-eight years later in front of the same cabin.

In 1978 the information available to Andriot was that the cabin had probably been used as a stagecoach stop on the old road to Louisville. I visited him in November 2006, and we talked by phone in November 2009. By then, several historians had reported more accurate information.

Mr. John Locke, originally from Louisville, built the cabin in 1806. He used the ground floor as a school while he lived upstairs. Shelbyville was only ten years old then (it was founded in 1796), so the cabin was outside the town. Another history relates that by 1830 the cabin was one of forty two-story log buildings in Shelbyville. Today few remain.

Andriot used the cabin only one year before selling it to a man for a western-wear business, who later sold it to a dentist who made an addition on the back, using the old building as his reception room. He lived on the second floor of the original cabin. The building was subsequently sold to a second, then a third dentist.

Bob Andriot, November 2006, Shelbyville, Kentucky.

I asked, "Was it rustic inside?"

Andriot said, "Not really. The walls were drywall. The problem with the building is that it has no foundation. The pine floor and logs were set right on the ground. It's been vacant for a couple of years, and it's fallen into disrepair again. It's so sad. It's been abandoned. To rebuild it again, you would probably have to take it down, put in a foundation, and rebuild from there up."

Bob continues to reclaim old buildings. Prior to their renovation of a 1902 home in order to open the Bell House Restaurant, Bob with his wife and his son BJ remodeled W. J. Andriot's Paint-Wallpaper-Blinds Store, which BJ now owns and operates. There you'll find the Blue Highways Café, which serves coffee and cappuccino to customers while they pick colors and design their own renovation projects. I told Bob, "When you see that Blue Highways Café sign done in the same script as used on the cover of the first edition of *Blue Highways*, it's obvious being in the book had an effect on your life."

"We were at a funny point in our life then. We'd had a couple of tragic things happen, and we weren't looking for publicity. I think the neatest part about *Blue Highways* is—and I was never much of a reader—but after the book came out, it was so neat to receive messages from people who'd lived here and moved away and who'd read the book and sent us clippings from, like, the

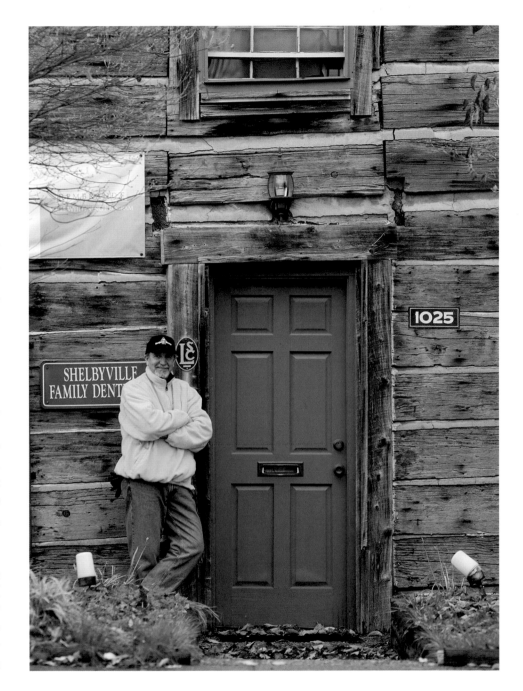

Atlantic Monthly or the Chicago paper. We would have people traveling the *Blue Highways* and stop and want to meet us. It was just so cool. For us that was the biggest joy of the book. We keep a couple copies over at BJ's Paint Store, and we still today make reference to the book. The picture that's in the book we've got hanging on the wall now. And we've got all these old pictures of Shelbyville hanging up. We've got probably forty to fifty of them. One of them is the picture in the book of me leaning on the cabin door. That opens the door to share the story. It's been good."

I asked, "When *Blue Highways* first came out, was there radio or television coverage locally?"

"Not locally. But at that time 'Good Morning America' contacted us and wanted to do a story on us—come to Shelbyville—you know how they do those little clips on the morning show. We actually refused to do that. We turned them down. I'm thinking, this is kind of getting disruptive to my life. The last thing I wanted to do was be on national television."

Bob Andriot in the Blue Highways Café, Shelbyville, Kentucky, on Route 53 and US 60.

Note the same typeface used on the original *Blue Highways* jacket cover. I first tracked down Bob Andriot at this store in November 2006. At that time, he sent a message to Heat-Moon via the digital recording device in my camera: "Hi Will. How you doing? It's been a long time. I hope you haven't aged as much as I have, and I hope you've made a whole lot more money than I've made. But I'm still in Shelby County, and you're rolling all over the country. It's good to talk to you, and I hope to see you sometime."

Smitty's, Kentucky, US 60.

Several miles west of Frankfort, Smitty's still stands. I didn't see things Heat-Moon saw—a Frankfort city bus, an ice-cream wagon, or an offspring of the piebald mongrel (*BH* 14–15)—but Smitty's still has a couple of almost anything else you might ever want.

Kentucky Route 33, south of Lexington.

Heat-Moon described driving by "creosoted tobacco barns" and "the black lines of plank fences that met at right angles," creating a crossword puzzle out of the countryside (*BH* 18).

The Palisades, Brooklyn Bridge, Kentucky, US 68.

Limestone bluffs on the Kentucky River, seen from the US 68 bridge. I knocked on every door in the Palisades area and found only one person home. She said that Bill Hammond, builder of the sixty-four-foot boat *Bluebill* (*BH* 18), died years ago, and his wife, Rosemary, had moved, but she didn't know where. The fate of the *Bluebill*? Had it ever graced the water? She didn't know.

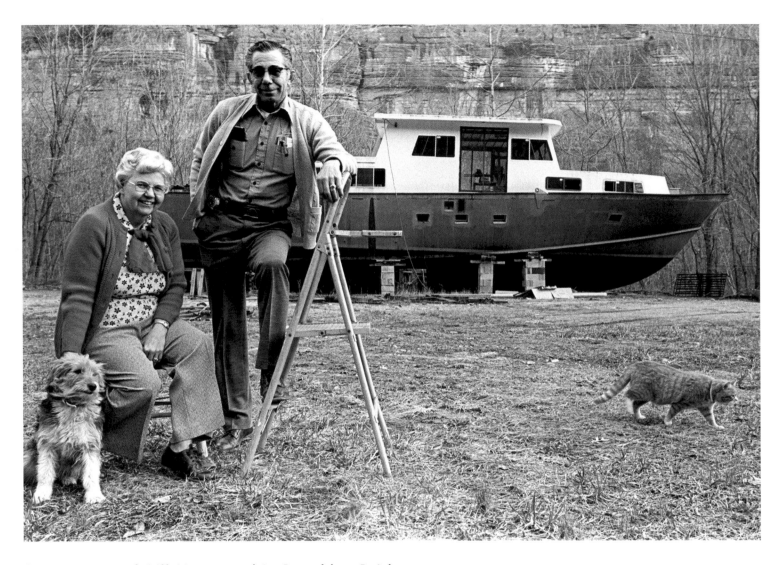

Rosemary and Bill Hammond in Brooklyn Bridge,
Kentucky, US 68 (photograph by Heat-Moon, 1978).

The Hammonds stand in front of their dream in the making, the *Bluebill*, a sixty-four-foot boat (*BH* 19–22).

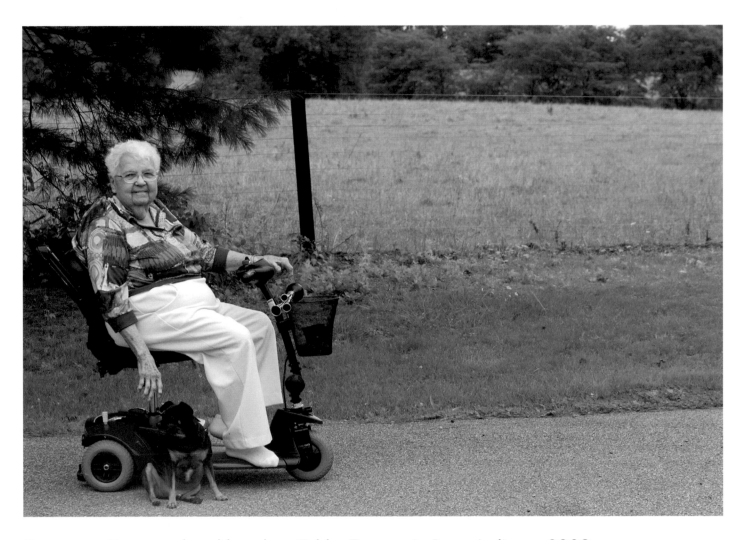

Rosemary Hammond and her dog, Tubby Tommy, in Peru, Indiana, 2009.

I learned that Rosemary Hammond had moved back to Peru where she and Bill grew up. I asked her, "Were you high-school sweethearts?"

She replied, "High school? We were grade-school sweethearts. We walked to school together a lot—he lived up in the next block." They shared dreams from childhood on, but their biggest dream took fifteen years to design and build from the keel up—the *Bluebill*.

When Heat-Moon passed through Brooklyn Bridge, Kentucky, in early spring 1978, he noted Bill Hammond had finished only the "hull, deck, superstructure." Rosemary told me that later that spring a record flood floated the *Bluebill* off its supports; but she was made to float, and she sailed beautifully at the end of her line. Five days later, as the water receded, the Hammonds eased her back onto her supports. In May 1984, the river came within eighteen inches of once again floating the *Bluebill*. Had it raised the hull, they wouldn't have needed two gigantic cranes later, to lift the seventy-ton boat into the Kentucky River on September 18 of that year.

The story of the *Bluebill* in *Blue Highways* had already given the Hammonds national exposure. In March 1984, they were interviewed on "Good Morning America" onboard the *Bluebill*, and part of the filming was also shown on CNN. So when the *Bluebill* was finally launched, Rosemary estimated there were about three hundred people, reporters from three or four television stations from Lexington and Louisville, and lots of newspapers—the *Danville Advocate Messenger*, the *Lexington Herald-Leader*, the *Louisville Courier Journal*, the *Harrodsburg Harold*, and the *Frankfort State Journal*—there to witness it.

"There was a great cheer as it touched the water," she said.

Rosemary's daughter Beth told me, "It was just amazing. I took my son, Mike, age twelve or thirteen, out of school. He had done several things to help. I'd been divorced since he was age three, so my dad was a real big father figure to him—so he wanted to be there. Dad and Mike spent several weeks going around to all the creeks in Miami County, Indiana. They gathered a jigger of water from each, and it went into a special bottle. That was the bottle that Mom used to christen the boat—our champagne we drank."

After fifteen years of building, the Hammonds realized their dream of living aboard the *Bluebill*. They spent about half of the next three years on the Kentucky River and the other half on the Ohio.

Rosemary added, "When we lived on the Kentucky, we had a high muddy bank. We had some old fire escape stairs put on the bank for me. I climbed out of there every day and went to school. That was a wonderful place in our life. It was a happy and most unusual situation that we got ourselves into."

In 1987 Bill's emphysema required them to leave the boat and move back to Peru. Bill died in September 1987, age sixty-seven, making the dream shorter than it might have been.

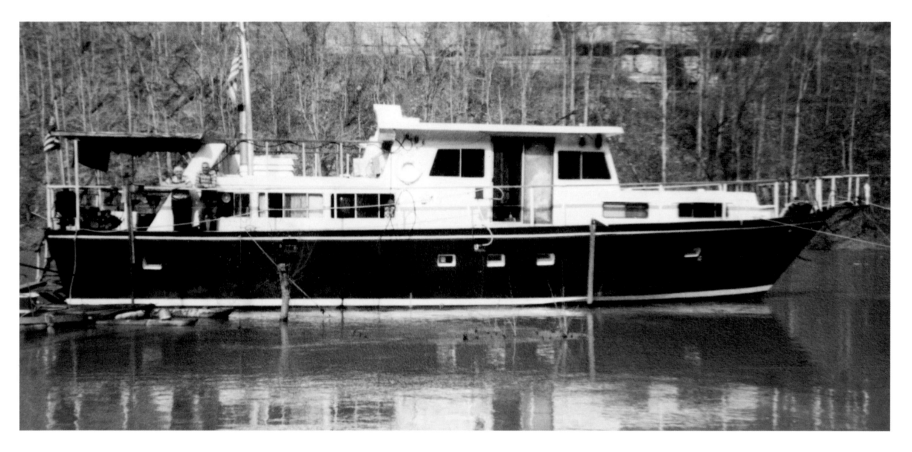

The Bluebill *on the Kentucky River in 1984 (this photograph and the ones on the following page provided by Rosemary and daughter, Beth Wright).*

In 1978 after seeing and hearing about Bill and Rosemary's nearly completed dream, Heat-Moon questioned Bill, "Dreams take up a lot of space?" Bill's reply, "All you'll give them" (*BH* 19–22).

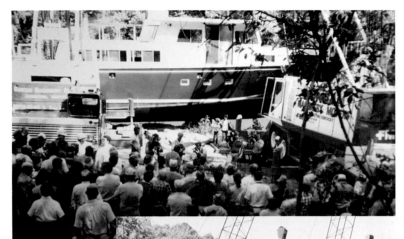

The Bluebill.

Several hundred family members and friends gathered behind the cranes on the banks of the Kentucky River to watch the launching of the *Bluebill*.

The launching of the Bluebill.

The *Bluebill* on September 18, 1984, was lowered by two giant cranes onto the Kentucky River. She graced the water for three years.

Rosemary and Bill Hammond on September 18, 1984.

The Hammonds celebrated their dream after fifteen years of work on the *Bluebill* by christening the boat with water collected from streams around their hometown, Peru, Indiana. They drank the champagne.

Spiral staircase in Trustees' Hall,
Shaker village, Pleasant Hill,
Kentucky, on Route 33.

This staircase with its outstanding workmanship epitomizes the Shaker village. It encircles visitors and can carry them to loftier heights—a notion central to the Shaker vision (*BH* 23–24).

*Stone wall around the Shaker village near
the junction of US 68 and Kentucky Route 33.*

In the Shaker village, Heat-Moon felt as though he was "standing in the future . . . because
they cared more about adapting to the cosmos than to a society bereft of restraint" (*BH*
23–24). Continuing south through Danville, Kentucky, and following US 127, Heat-Moon
crossed the border into eastern Tennessee.

Good Lard! Livingston, Tennessee, on Routes 111 and 85.

Heat-Moon commented on the number and size of lard containers in stores—one a thirty-eight-pound drum (*BH* 25). In November 2006, the largest weighed a mere twenty-five pounds.

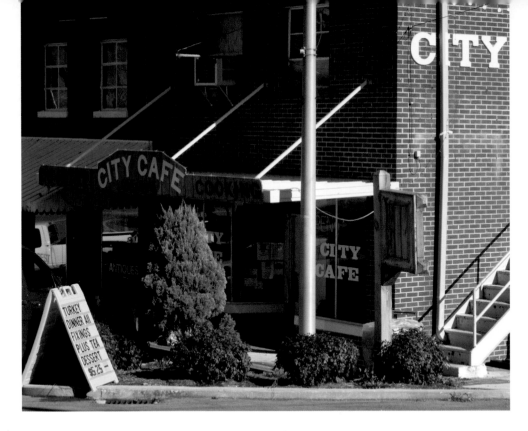

*City Cafe, Gainesboro, at the junction
of Tennessee Routes 85 and 53.*

When Heat-Moon visited the City Cafe, he wrote of the "almost infallible" calendar rating that allows a traveler to find "honest food at just prices" on the back roads of America:

No calendar: Same as an interstate pit stop.
One calendar: Preprocessed food assembled in New Jersey.
Two calendars: Only if fish trophies present.
Three calendars: Can't miss on the farm-boy breakfasts.
Four calendars: Try the ho-made pie too.
Five calendars: Keep it under your hat, or they'll franchise. (*BH* 26–28)

When I dropped by, the City Cafe was still a pleasant, relaxed gathering place for good coffee and food with a friendly staff.

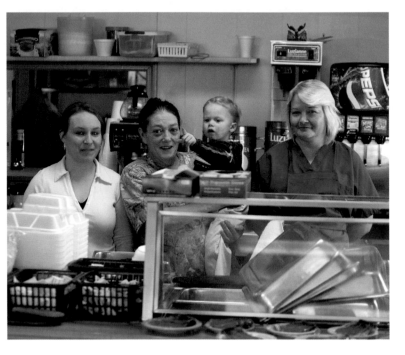

Inside the cafe, November 2006.

Nathan, grandson of the owner, directs Donna, Betty, and Rachel, the staff at the City Cafe, to get that man a cup of coffee.

34

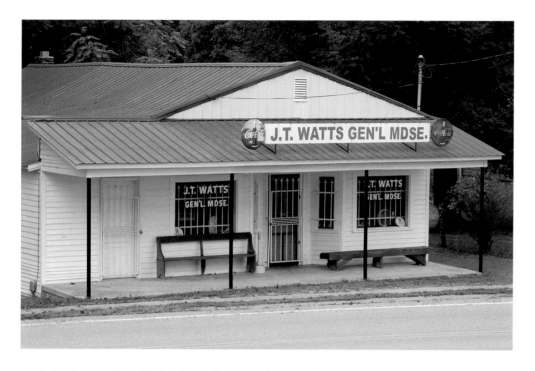

J.T. Watts Gen'l Mdse. Store, Nameless, Tennessee, on Route 290.

How Nameless got its name was one of my favorite stories in *Blue Highways* (*BH* 31–35), so I was especially excited to arrive in town on my first visit, one November morning in 2006. I couldn't raise a soul in town—a very unfriendly looking dog in the fenced-in yard did keep me from knocking on one door. So I missed the possible buttermilk pie and the Edison phonograph.

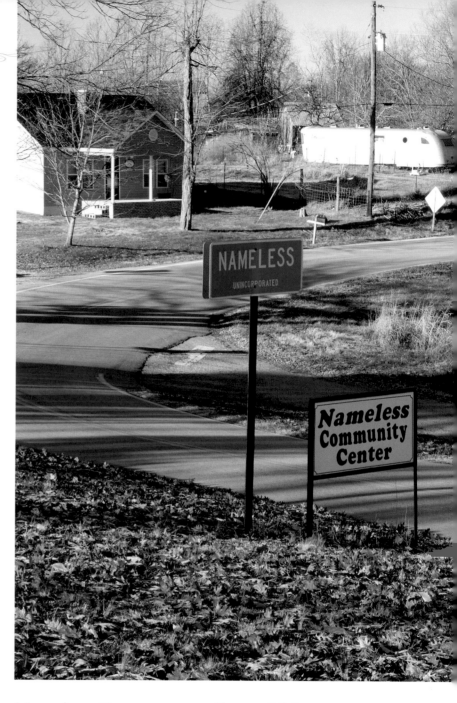

Nameless, Tennessee, on Route 290.

35

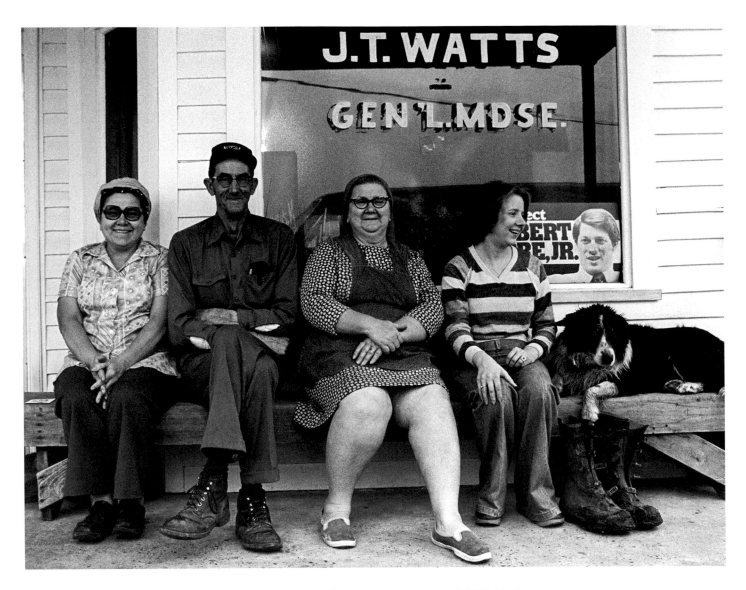

The Watts Family: Marilyn, Thurmond, Virginia, and Hilda in Nameless, Tennessee, on Route 290 (photograph by Heat-Moon, 1978).

Note the political poster in the window. First-term congressman Al Gore was running for reelection (*BH* 34).

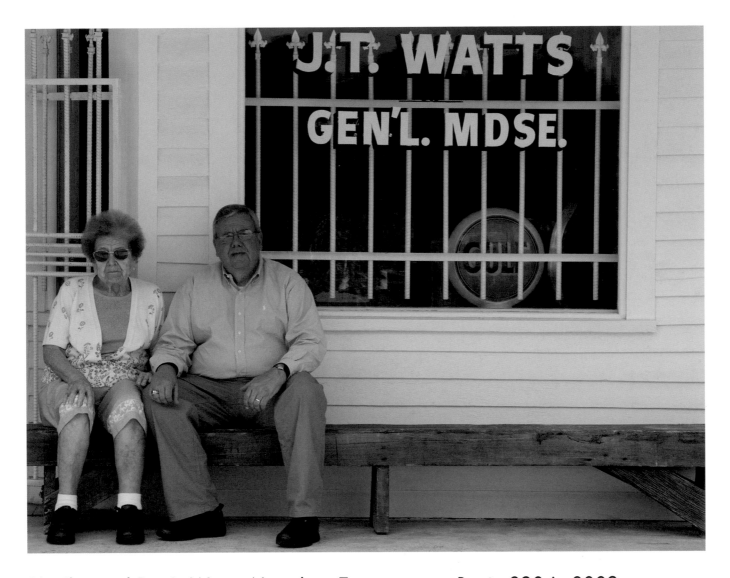

Marilyn and Davis Watts, Nameless, Tennessee, on Route 290 in 2009.

Davis is the son of Thurmond and Virginia Watts. He had completed school and was living and working in Cookeville, Tennessee, at the time of Heat-Moon's visit to Nameless in 1978 (*BH* 31–35). He and his Aunt Marilyn returned to Nameless in August 2009 for this photograph and gave me a tour of the store, now with protective bars on the windows.

Davis Watts told me that the store, with living quarters in the back, was his parents' home until the summer of 1978, when they moved to Cookeville, just months after Heat-Moon passed through Nameless. Thurmond said to Heat-Moon as he departed, "If you find anyone along your way wants a good store—on the road to Cordell Hull Lake—tell them about us." Heat-Moon told the world about it, but the book did not come out in print until almost five years later. Fortunately, the now perfectly preserved general store stayed in the family.

I asked, "Did your folks hear anything from friends or family when *Blue Highways* was first published?"

Davis said, "Oh sure, because it was on television and some excerpts from the book and photos were shown in several places."

For the most part, his parents were pleased with what Heat-Moon wrote about them. Davis went on to bring me up to date on the family members: "My dad died first on October 12, 1988, my mother on February 28, 1993, and my sister, Hilda, died suddenly on July 15, 2008, of a heart attack at age fifty-four. My Aunt Marilyn will be eighty-two in March."

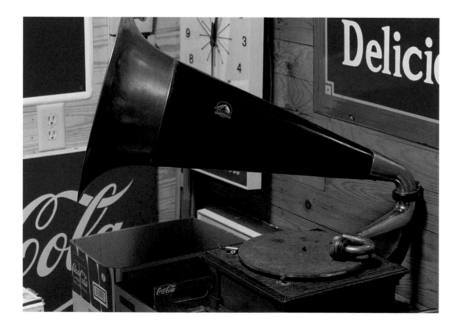

Davis and his wife restored the J.T. Watts Gen'l. Mdse. Store in 2004–2005 to how it was in the 1940s and 1950s. It is now open for business, more as a museum than anything else, on three Saturdays each year—Memorial Day weekend, the first weekend in October, and the second weekend of December.

With her son Mark's help, Marilyn transferred to her motorized scooter and then to the same bench she sat on for Heat-Moon's 1978 photograph on the front porch of the store. I noted too late that she was sitting at the wrong end of the bench, and with some difficulty, she moved to the far end and a little breathlessly said, "All of them's dead that was in that picture but me—and I'm just about dead. I can't stand up—my legs get to shakin' like that"—giving a wiggle of her hand.

After the photograph, Davis said, "Why don't you come in and get a Coke or something?" So I did, one in the green six-ounce bottle, along with a Moon Pie. The store was still lit by bare bulbs, and the iron stove still stood in the rear of the rectangular room. My time exposures on a tripod were upset every time someone walked near me and vibrated the sagging oak floor. The wooden table and checkers game were still there; and earthen jugs, canned goods, and clocks still lined the wooden shelves, though Thurmond's "two thousand clocks" were now only a few.

Madison Wheeler, the man who directed Heat-Moon to the Watts Gen'l. Mdse. Store, died in 1987. His philosophy was, "Satisfaction is doin' what's important to yourself" (*BH* 29–31). The road behind the store leads into a hollow where his family cemetery is.

An Edison phonograph with its "morning-glory blossom for a speaker."

This later model was still in the side room. The one Thurmond used when he played "My Mother's Prayer" for Heat-Moon used wax cylinders (*BH* 33).

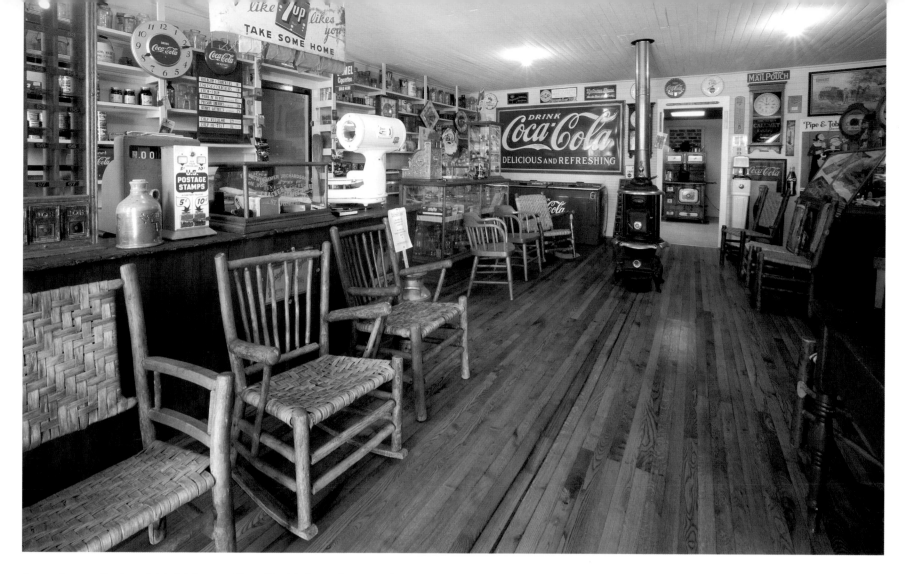

Interior of the J.T. Watts Gen'l. Mdse. Store, Nameless, Tennessee, on Route 290.

Heat-Moon asked Thurmond Watts if he built this store. Thurmond replied, "I built this one, but it's the third general store on the ground. I fear it'll be the last. I take no pleasure in that. Once you could come in here for a gallon of paint, a pickle, a pair of shoes, and a can of corn."

"Or horehound candy," Miss Ginny said. "Or corsets and salves. We had cough syrups and all that for the body" (*BH* 32). From Nameless, Heat-Moon traversed northeast Tennessee into North Carolina.

North Carolina

Sandy Creek in Franklinville, beside North Carolina Route 22 (BH 43–45).

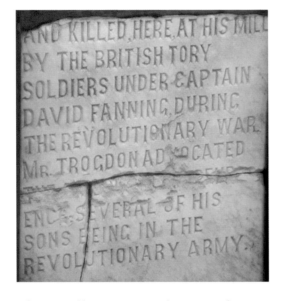

The William Trogdon tombstone.

This marker is on display in the Ramseur, North Carolina, Community Museum. In 1783, William Trogdon was shot and killed close to his mill beside Sandy Creek. Heat-Moon's great-grandfather eight generations back, Trogdon had been providing supplies to the Carolina militia for several years during the Revolutionary War. David Fanning, a Tory leader, had him hunted down. William's sons buried him beside Sandy Creek where he fell—or so says the family history (*BH* 43).

Sandy Creek reservoir, Franklinville, North Carolina, on Route 22.

With the building of the Sandy Creek reservoir in 1977 (now the Kermit G. Pell Recreational Facility), the remains of the revolutionary patriot William Trogdon—or a few "token spades of dirt" that represented the man—were moved to higher ground beside the reservoir. "Whatever was left of the old miller . . . was now under ten feet of Sandy Creek."

Heat-Moon went looking for his ancestor's grave marker after first talking to Kermit Pell (then the water commissioner)—and later to Noel Jones.

Jones said, "Best you wait 'til mornin', or you'll be wipin' shadows all the way."

But Heat-Moon didn't wait. As he was hiking to the site, the woods around him got darker and darker, the undergrowth thicker, and his imagination of what surrounded him blossomed. It is then he introduces us to his mother's jest of making up newspaper headlines to illustrate "foolhardy activity." He could hear her saying, "Remains of Lone Hiker Found." She would give details from the story . . . "only the canteen was not eaten" (*BH* 44–48).

From this point forward on my travels of *Blue Highways*, I would also experience similar headlines—often associated with my own questionable judgments.

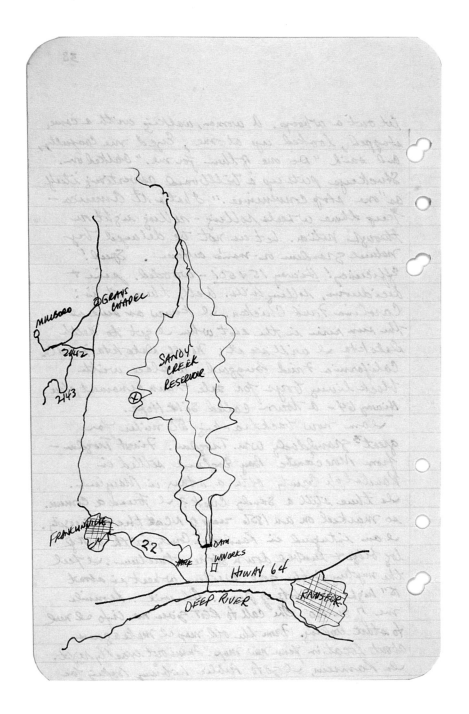

Heat-Moon's logbook map of the Sandy Creek reservoir, Franklinville, North Carolina, on Route 22.

He drew a map on the back of a journal entry so that when he returned home he would have a topographical image of the reservoir. The X marks the spot where he found his ancestor's grave marker.

Heat-Moon told me, "This crude map accurately led a genealogical researcher to the grave marker, although in 1978 I drew it from memory."

When I visited Ramseur in 2006, the new community museum had just opened to the public the day before. I thought maybe someone would know about the William Trogdon grave site. When I walked in and saw not one but *two* stone markers for William Trogdon, I was stunned. The second marker was for William Trogdon III, grandson of the patriot—born September 1, 1774, died October 8, 1864.

On his hand-drawn map, the word "park"—just to the right of "22" and not easily read—shows where Heat-Moon spent the night. After his nocturnal hike, he describes fitful sleep and hearing "something moving in the near woods . . . something was crouching outside" (*BH* 49).

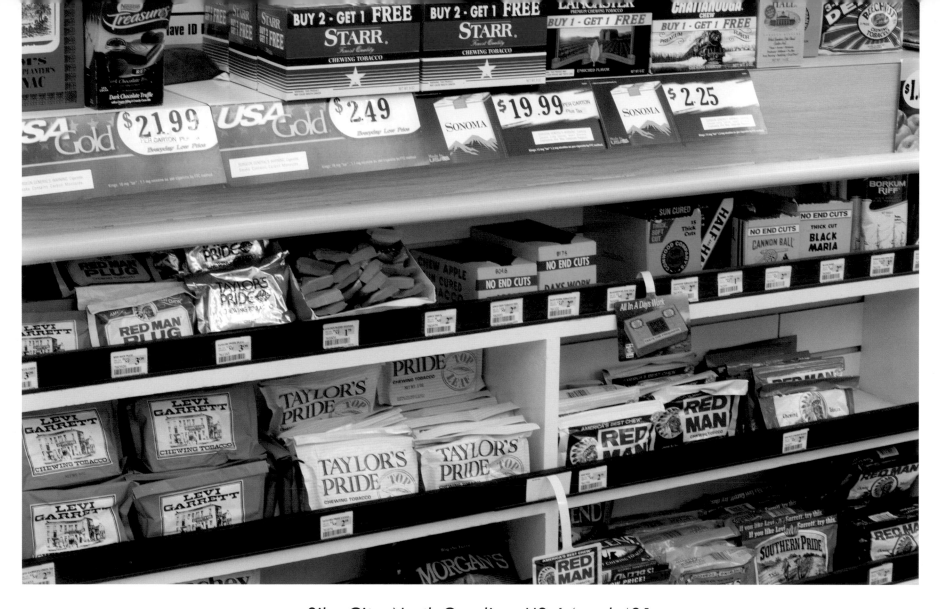

Siler City, North Carolina, US 64 and 421.

Heat-Moon found twenty-two kinds of chewing tobacco in a store in Siler City (*BH* 51). I count only twenty in this image—maybe I should have used my wide-angle lens. From twenty-two choices to twenty: does that represent a 9 percent success rate for the surgeon general in twenty-eight years?

Cypress Trees "cooling their giant butts," North Carolina, US 64.

Heat-Moon noted clean but dark swamp water—from the tannin in the cypress roots (*BH* 54).

Pamlico Sound in North Carolina, on Route 306.

This body of water is a salt sea eighty miles long and thirty miles wide, separated from the Atlantic Ocean by the Outer Banks of North Carolina. Heat-Moon observed, "because of the Pamlico Sound . . . North Carolina has more water surface than all but two other contiguous states" (*BH* 65).

Sundown on Emerald Isle, North Carolina, on Route 58.

Depending on where you leave the *Blue Highways* path—whether at New Bern, North Carolina, or farther south at Pollocksville—it's only between forty and sixty miles to Emerald Isle on the Outer Banks and its wide beaches. How do you get a sunset on the east coast? The angle of the banks—just seven or eight degrees off a true east–west direction—allows a sundown over the water on this part of the east coast (*BH* 66).

Emerald Isle, North Carolina, on Route 58.

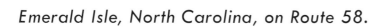

As Heat-Moon crossed the Pamlico River on a ferry, "Laughing gulls materialized from the air to hang above the prop wash and shriek their maniacal laugh . . . as they dropped like stones from twenty feet into the cold salt scuds." (*BH* 65–66). Here they rest at night.

From the Pamlico Sound and River, Heat-Moon headed southeast through New Bern, Elizabethtown, and Lumberton into South Carolina.

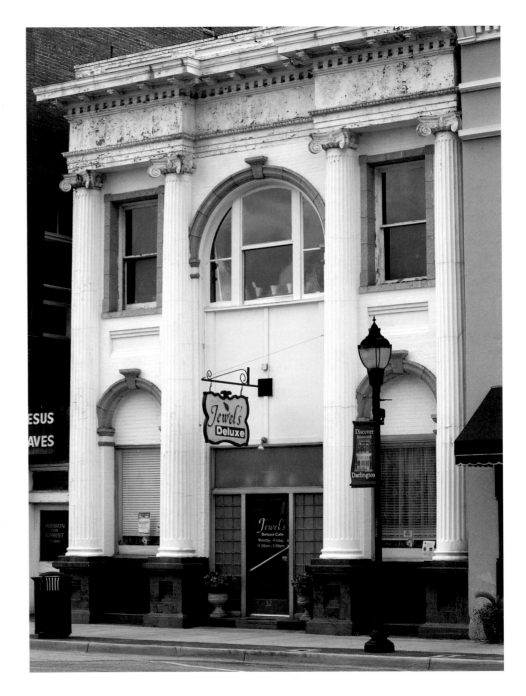

Jewel's Deluxe Cafe, Darlington, South Carolina, on Route 34.

Gone are the neon, icy letters, and the waitress who "had developed the ability to make a customer wish he'd thrown up on himself rather than disturb her." I was efficiently served a delicious lunch. Heat-Moon "went in happy" but came out otherwise (*BH* 67–68). In 2007, I went in curious and came out happy.

Up to its belly.

In Heat-Moon's travels across South Carolina on Route 34 on a hot spring day, he saw a variety of things: a gushing and refreshing artesian well, kudzu taking over fields and forest, and a horse standing "up to its belly in a pond of rust-colored water" (*BH* 69). I looked for a horse but had to settle for a cow.

The artesian well.

It's still flowing strong (*BH* 69). Palm trees, now in the roadside park, make it look like an oasis.

Kudzu.

This plant was first brought to the United States in 1876 from Japan and was used in the 1930s and 1940s to control soil erosion. It flourished in the southeast United States where it can grow up to sixty feet a year, prompting Heat-Moon to observe it running "through Dixie, showing less restraint than Sherman" (*BH* 71).

Cotton fields of W. A. Berry, Bishopville, off South Carolina 34.

As Heat-Moon traveled this road, he realized the history of the region boiled down to four words: "indigo, rice, cotton, tobacco" (*BH* 70). Cotton was still the predominant crop around Bishopville, home of the South Carolina Cotton Museum. For anyone who has grown up in cotton country, the sight of the perfect rows will always conjure up warm memories of the feel and scent of cotton and its gins.

I met W. A. Berry at his home near this field. His southern drawl made me smile and look for a place to prop up my feet. His voice should be packaged as an antidote to today's often rushed existence. I proceeded west on South Carolina 34, but at a slower pace after meeting Mr. Berry.

Wateree River, South Carolina Route 34.

"South Carolinians like their rivers with paired Indian vowels." Besides the Wateree, Heat-Moon lists the Congaree, Santee, Pee Dee, Combahee, Keowee, Tugaloo, and the Ashepoo (*BH* 70). There's also the Oolenoy, Chattooga, Enoree, Coosaw, and Coosawhatchie Rivers. Get a native South Carolinian to pronounce the names and they are as enchanting as the Wateree looks.

Newberry, South Carolina, on Route 34.

Heat-Moon described "columned houses, with cast-iron fences, and gardens behind low brick walls." He captured the town in eight lines—or perhaps even just one word: "lacy" (*BH* 71).

Ninety Six National Historic Site, South Carolina, on Route 248.

This path is the old Ford Island Road, one of the Cherokee paths still visible at Ninety Six National Historic Site. The town and fort got the name because it was estimated they were ninety-six miles from Keowee, the center of the Cherokee Nation.

The eight-pointed star-shaped fort, now restored, was the site of the longest siege of the American Revolution (*BH* 72–75).

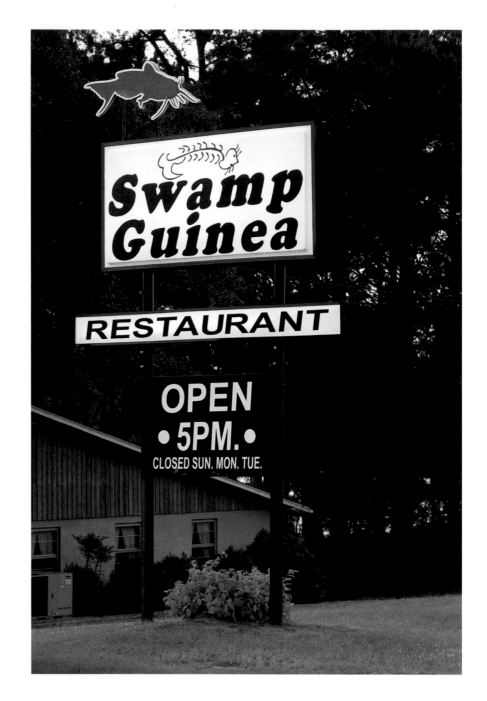

The new Swamp Guinea Restaurant, Hartwell, Georgia, on Route 77.

Now twenty miles north of Georgia 72, the Swamp Guinea's Fish Lodge that Heat-Moon visited near Colbert and Hull, Georgia, closed not long after he passed through (*BH* 76–77). Brian and Judy Burroughs reopened the eatery in Hartwell and are still serving an "All You Can Eat" menu: platter after platter heaped with fish, shrimp, and hushpuppies.

University of Georgia, Athens, Georgia, on Route 72.

Heat-Moon walked off his Swamp Guinea dinner on the campus and observed couples entwined everywhere (*BH* 77). I visited in the morning and found only this tree and fence entwined. The other entwining occurred later.

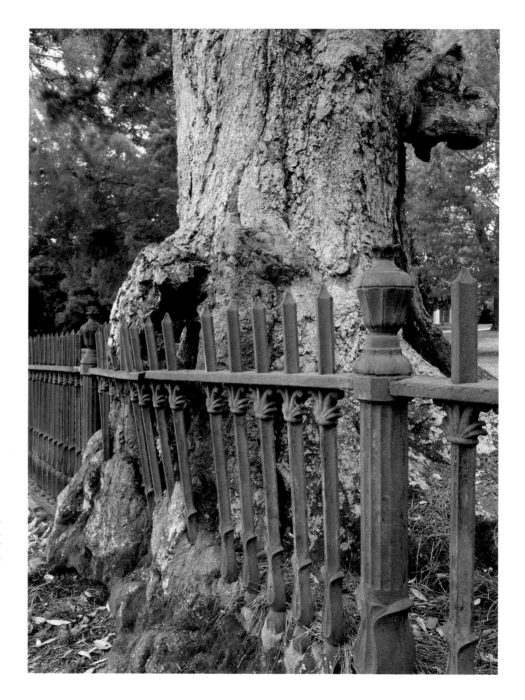

Near Senoia, Georgia, on Route 16. (BH 78)

Georgia Route 20, near the junction
with Georgia 10 (BH 78).

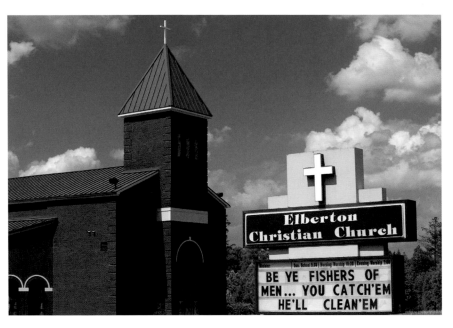

The Winner—Elberton Christian Church,
Elberton, Georgia, on Route 72.

The Baptist churches in the South had a way with names, Heat-Moon pointed out—Baby Farms Church, Sinking Creek, Little Doe, and Sweet Home (*BH* 78). As I followed his path, the churches still had creative names—but I was even more entertained by their signs.

56

Monastery of the Holy Spirit, Conyers, Georgia, on Route 20.

As Heat-Moon passed through Conyers on Georgia 20, he saw a cross on the top of a water tower—even in the Bible Belt, it seemed out of place. So he drove up a magnolia-lined drive to find Patrick Duffy, a Trappist monk (*BH* 78–88).

When I visited the monastery in June 2007, I learned that Father Patrick Duffy had been assigned to the San Jose Parish, New Mexico. In May 2009 I visited him at his home in Las Vegas, New Mexico. He had a small living room, two bedrooms—one a well-stocked library. We met at noon. (He said, "I'm not an early riser.") After twenty years as a monk in Conyers, Patrick moved to Albuquerque where he spent a year working with the poor. "Then they sent me out here. With fewer people choosing a religious life, they had to scrape the bottom of the barrel—that's how they got me," he said with a smile.

"Out here" was San Jose. "The parish had three active missions and a broken-down mission," he explained. The broken-down mission was a small church in Anton Chico that was in such disrepair the insurance company considered it a liability. "I asked one of my parishioners, Pacifico Romero, to put a wire across the building's doors to keep the insurance company happy. 'Padre,' he says, 'Can I work on it?' I said, 'Pacifico, God sent you.' He went to work—it took seven years" to restore the church.

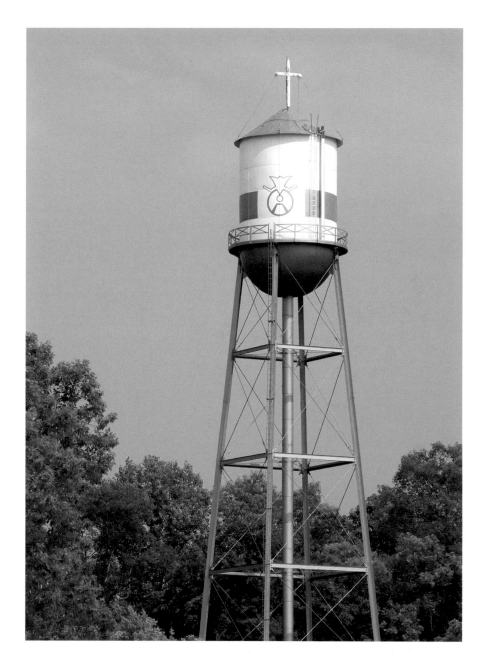

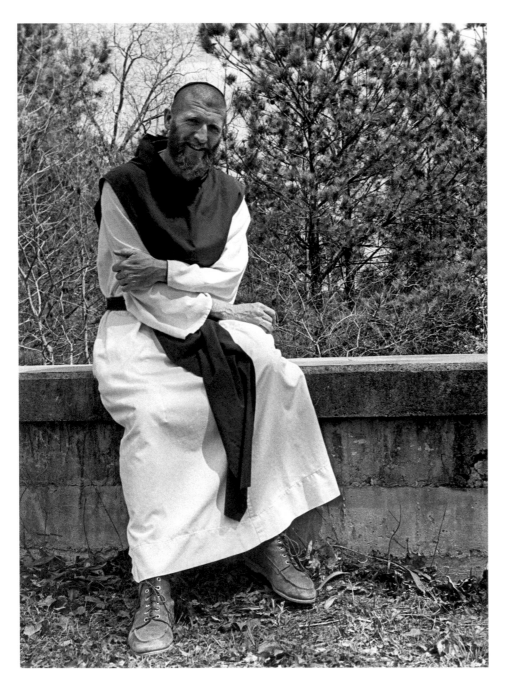

Brother Patrick Duffy at the Monastery of the Holy Spirit, Conyers, Georgia (photograph by Heat-Moon, 1978).

He was the parish priest until his retirement in 2005 when he had to have a cancerous kidney removed and brain surgery for a metastasis.

I asked whether being written about in *Blue Highways* had any effect on him.

"It was a pain in the ass," he said. "People would think I'm some kind of guru. I would get notes from people, and people would come to the monastery looking for me. There are a lot of people out there needing answers. That's why people come to monasteries—wanting to talk to monks—'What's it all about?' If anybody comes to me and I can help him, I will; but I'm not going to hang out a shingle, and I'm not going to be answering fan mail."

We spent the afternoon seeing the churches of his parish and visiting multiple parishioners. His love and respect were willingly returned in the form of hugs and playful banter—he obviously enjoyed his flock, and they, their shepherd. With the sun receding, we started back to Las Vegas.

Father Patrick Duffy in front of the Anton Chico Mission—part of the San Jose Parish, New Mexico.

Patrick was pointing out some distant mountain range, and it reminded him of a certain prayer years earlier. "I had traveled into France on my motorcycle. I was low on gas and pulled into a station to fill up but didn't know any French. I was silently praying, 'Help me communicate with the attendant' when I remembered the prayer, 'Hail Mary, full of grace' and extracted the Latin word 'full' and pointed to the tank. The attendant immediately understood—my prayer was answered."

Patrick may no longer be assigned a parish with four missions, but he is still working on other missions. Since I saw him in May 2009, he had a lump in his hand removed—also a spread of his cancer. Chuckling, he told me, "God likes to take you a little bit at a time."

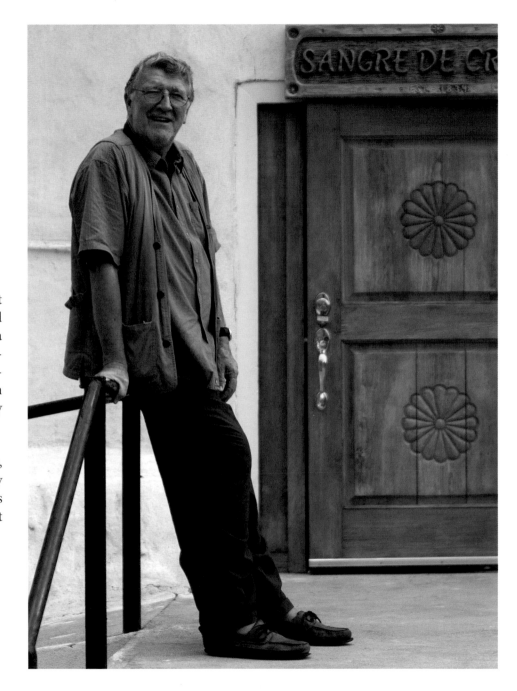

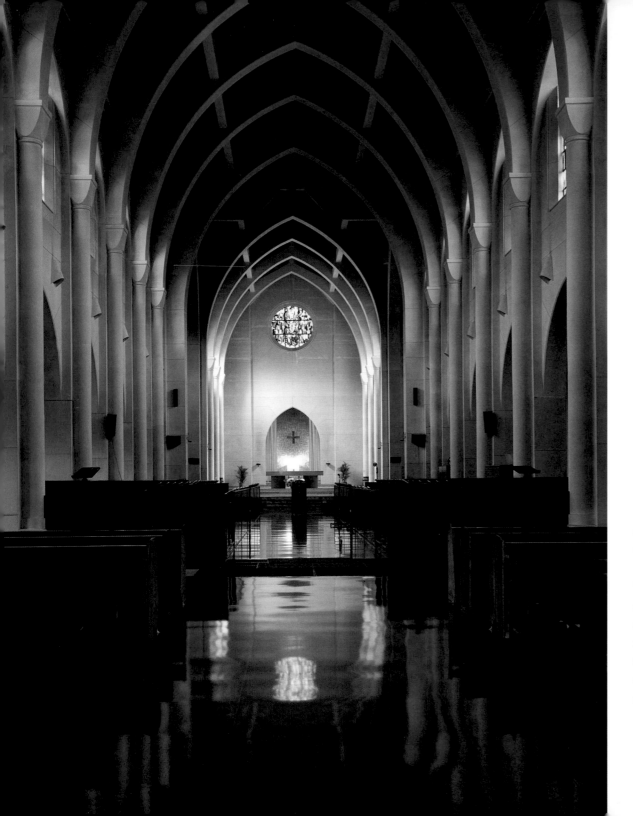

Monastery of the Holy Spirit, Conyers, Georgia, on Route 20.

"The monks filed noiselessly into the great, open sanctum and sat facing each other from both sides of the choir. At a signal I didn't perceive, they all stood to begin the antiphonal chanting of plainsong. Only younger ones and I looked at the hymnals. The sixty-five monks filled the church with a fine and deep tone of the cantus planus, and the setting sun warmed the stained glass. It could have been the year 1278" (*BH* 82–83).

Troublesome Creek, Georgia, on Route 155.

Following the blue roads south of Atlanta, Heat-Moon crossed over Troublesome Creek and then the Chattahoochee River, just above where it becomes the border between the lower halves of Georgia and Alabama (*BH* 91).

The Chattahoochee River, Georgia, on Route 34.

About twelve miles after the Chattahoochee River, Georgia 34 becomes Alabama 22, which Heat-Moon followed to Alexander City, Clanton, and on to Selma (*BH* 91).

Alabama

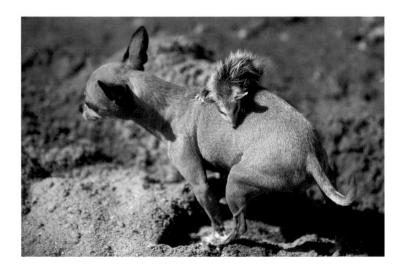

Beside Hillabee Creek, Alabama, on Route 22, east of Alexander City.

As Heat-Moon traversed Alabama on Highway 22, an "outbreak of waving happened." He cited a city motto in Alabama, "Where folks are friendly" (*BH* 93). One friendly family introduced me to their Chihuahua; it had become a surrogate mom to an infant opossum.

Water Avenue near the Pettus Bridge in Selma, Alabama, just off Alabama 22 and US 80.

When Heat-Moon met James Walker and Charles Davis in the spring of 1978, they had seen little if any change in race relations in Selma since March 7, 1965—the day Martin Luther King, Jr., and six hundred men and women gathered at Brown's Chapel, marched down Water Avenue, and tried to walk across the Edmund Pettus Bridge, against insurmountable odds. But Walker, like Dr. King, had a dream in 1978.

He told Heat-Moon, "Me? I feel I can be President of the United States" (*BH* 100).

When I passed through Selma in October 2006, Barack Obama had yet to declare his candidacy for the presidency of the United States, something that would occur a year later.

Edmund Pettus Bridge,
Selma, Alabama, US 80.

After the conversation with Heat-Moon, Walker went on to get a degree at Concordia College in Selma. He worked unofficially as a children's counselor and Little League coach. "He had a beautiful personality for children," his wife, Lula, told me. His daughter LaToya said he helped people change a lot of bad attitudes and look at things in a more positive way.

I asked Lula whether James was pleased that he appeared in *Blue Highways*?

She replied, "He bragged about that book. We had a couple copies. They've gotten away or are with family members, but my youngest daughter still has a copy."

James Walker died of an aneurysm in March 2000 at forty-six. At age twenty-four, he said to Heat-Moon, "We got potential. First, though, brothers gotta see what's on the other side of Pettus Bridge" (*BH* 97–99).

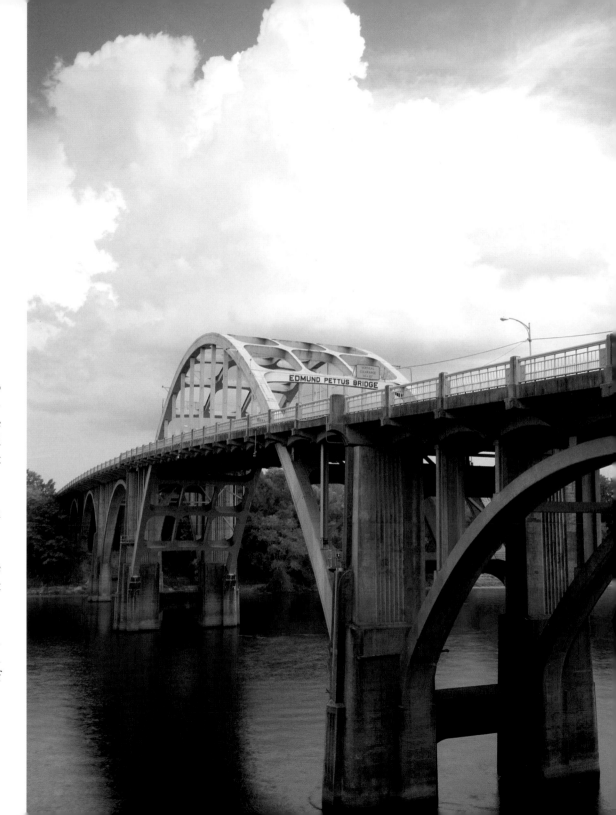

Natchez Trace Parkway, south of Ofahoma, Mississippi.

"For miles no powerlines or billboards. Just tree, rock, water, bush, and road. The new Trace, like a river, followed natural contours and gave focus to the land" (*BH* 104). This national park is a 444-mile-long two-lane highway with limited access and no commercial traffic that runs from just below Nashville, Tennessee, to Natchez, Mississippi.

Approaching storm, Ross Barnett Reservoir,
Mississippi, beside the Natchez Trace Parkway.

Created by a dam on the Pearl River, the reservoir parallels the eastern edge
of the trace for about twenty miles northeast of Jackson, Mississippi. From
Jackson, Heat-Moon drove west to Vicksburg and into Louisiana (*BH* 104–7).

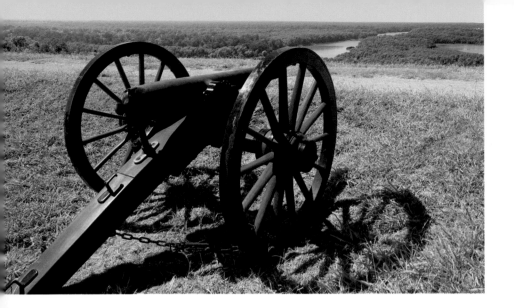

Mississippi River from the Vicksburg Battlefield, Vicksburg, Mississippi, US 80.

This cannon once fired shells at Union gunboats on the Mississippi. Heat-Moon surmised that "anything—a rock, a stick—falling from that height must have hit with a terrible impact" (*BH* 107).

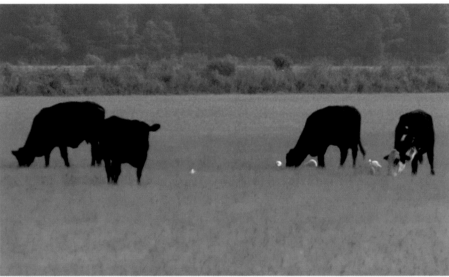

Louisiana

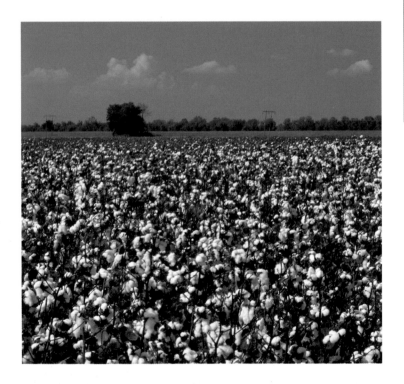

Near Ville Platte, Louisiana, US 167.

Three decades before this photograph, Heat-Moon saw "a scene of three colors: beside a Black Angus, in a green pasture, a white cattle egret waiting for grubbings the cow stirred up" (*BH* 110).

"Low and level cotton fields" of Louisiana, US 80.

Heat-Moon wrote, "Once a big oak or gum grew in the middle of each of these fields," a place for a farmer to shade his team or have a meal (*BH* 107). A rare one still exists.

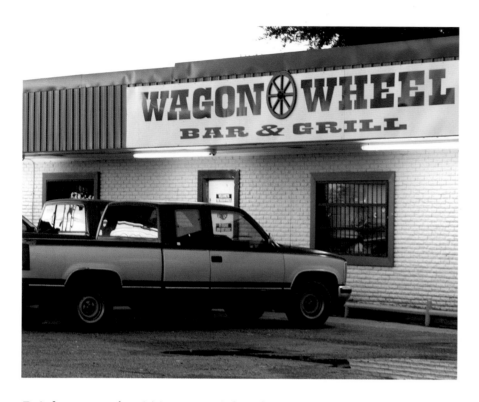

Eric's, now the Wagon Wheel Bar and Grill, Lafayette, Louisiana, on Route 31.

Many of Heat-Moon's five-thirty taverns were difficult to track down (*BH* 112–15). Since 1978, the Eric's he visited subsequently became Buddies and Friends, then Mamie's, then Saddle Tramp, then Robin's. For years now, it has been the Wagon Wheel.

As for Tee's, I stopped at multiple taverns to ask about it. I was close to giving up when a bar owner at the Lady Luck Lounge told me that Tee's full name was La Toupee's, but it was torn down years ago.

But I did find Mulate's, a Cajun bar and restaurant at the edge of Breaux Bridge. The sign on the door claims the restaurant is fulfilling its role in the preservation of the Cajun culture with live Cajun music. And if you're looking for a business card, look no further—the ceiling is covered with them.

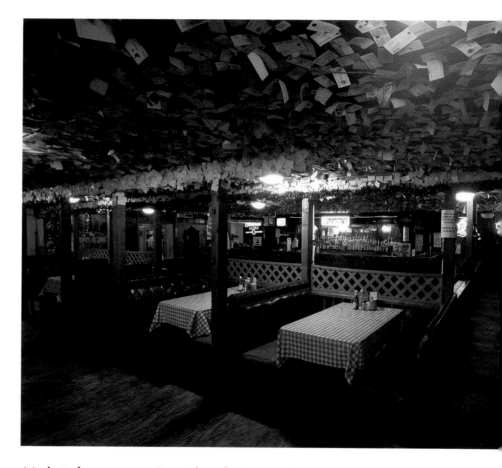

Mulate's, preserving the Cajun culture, Breaux Bridge, Louisiana, on Route 94.

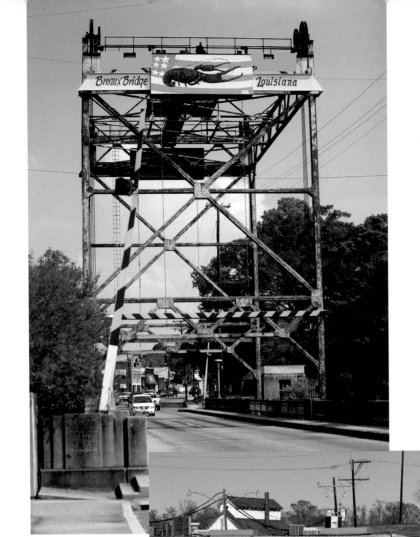

Breaux Bridge, Louisiana, on Route 31.

Heat-Moon wrote that "Breaux Bridge, on the Bayou Teche, stirred slowly with an awakened sense of Acadianism" (*BH* 116). It still claims to be the Crawfish Capital of the World.

Pat's Fisherman's Wharf Restaurant, Henderson, Louisiana, on Route 352.

It was here Heat-Moon ate a tray of "mudbugs [crawfish]" (*BH* 116).

Bag of live, fresh mudbugs.

As Heat-Moon ate his pile of boiled crawfish at Pat's, his waitress asked him, "Did they eat lovely like mortal sin?" (*BH* 116).

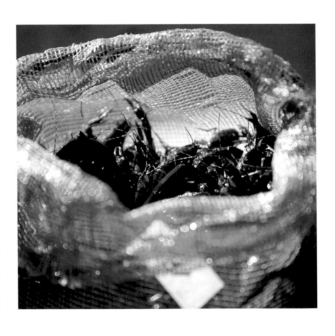

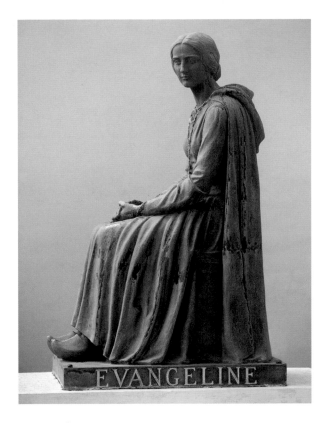

Emmeline (or Evangeline, or Dolores del Rio),
St. Martinville, Louisiana, on Route 31.

This statue, nestled in the Poste de Attakapas Cemetery behind and immediately adjacent to the Catholic church Saint Martin de Tours, sits above the grave of Emmeline Labiche (*BH* 117–18). The name on the statue, however, is Evangeline, the name of Henry Wadsworth Longfellow's heroine in "Evangeline: A Tale of Acadie."

The poem was the inspiration for two silent movies. A 1929 version starred Dolores del Rio, who posed for the statue. Today we have a trinity: the grave of Emmeline, Evangeline's engraved name, and the face of Dolores del Rio.

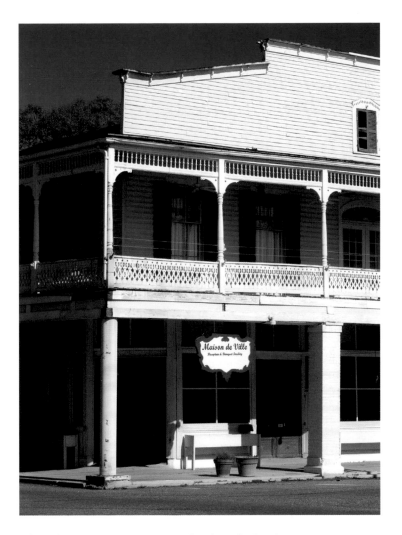

The former Maurice Oubre's bakery in
St. Martinville, Louisiana, on Route 31.

"St. Martinville was pure Cajun bayou, distinctive, and memorable in a tattered way. Wood and iron galleries were rickety, brick buildings eroded, corrugated metal roofs rusting" (*BH* 118). The old bakery is now the Maison de Ville, a reception and banquet facility.

Presbytere Flags, St. Martinville, Louisiana, on Route 31.

These flags hang on the front of the Presbytere, the priest's home, for the Saint Martin de Tours Church (*BH* 118). They represent the five governments under which the church parish was subject. From left to right, they are France (Bourbon line), 1752–1762; Spain (Bourbon line), 1762–1800; First French Republic (Napoleon), 1800–1803; United States (Louisiana Purchase), 1803–1861; and the Confederacy (the early seven-star Confederate National Flag), 1861–1865.

I searched for Barbara Pierre while in St. Martinville (*BH* 118). Two women at a convenience store told me she died about 2004.

Moss-covered canopy, on Louisiana Route 31.

"Blue road 31, from near Opelousas, follows the Teche through sugar-cane, under cypress and live oak, into New Iberia" (*BH* 124). South of St. Martinville is Keystone Oaks and its live oak and moss-covered canopy.

Shadows on the Teche, New Iberia, Louisiana, on Route 31.

"New Iberia gave a sense of both the new made old and the old made new" (*BH* 125). Shadows on the Teche, a restored mansion, was a prime example of the latter.

Evangeline Theatre, New Iberia, Louisiana, on Route 31.

Many places were named after Evangeline, Heat-Moon noted, including Evangeline Downs, Speedway, Thruway, Drive-in, even the Sweet Evangeline Whorehouse (*BH* 111–12). My findings were not as exciting: the Evangeline Theatre, the Evangeline State Park, and the town of Evangeline, north of Jennings.

Bayou Teche, from the backyard of Shadows on the Teche, New Iberia, Louisiana, on Route 31.

"Navigable for more than a hundred miles, . . . [the Teche] was the highway from the Gulf into the heart of Louisiana . . . long before roads came. Half of the eighteenth-century settlements in the state lay along or very near the Teche: St. Martinville, Lafayette, Opelousas, New Iberia" (*BH* 124).

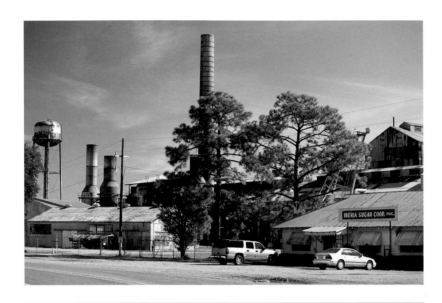

Iberia Sugar Factory, Louisiana Route 31.

Motoring across the southern part of the state, Heat-Moon jotted down a string of items that demarcate Louisiana: a sugar factory, "cemeteries jammed with aboveground tombs," Black's Oyster Bar, live oaks, and "shrimp trawlers at Delcambre" (*BH* 125).

Abbeville Cemetery, Louisiana Route 14.

Locally, these tombs are called box tombs.

Black's, Abbeville, Louisiana, on Route 14.

Heat-Moon saw Abbeville as his last chance for Cajun food. After eating at Black's, he was wishing "the British had exiled more Acadians to America if only for their cooking" (*BH* 125).

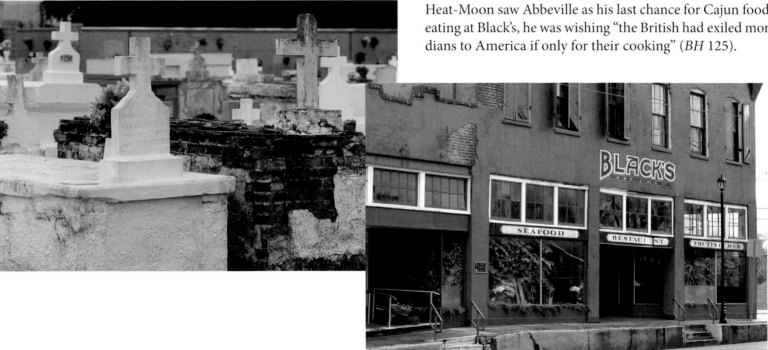

Abbeville, Louisiana, on Route 14.

It is "a town with two squares: one for the church, one for the courthouse" (*BH* 125). This square is near the church.

Shrimp trawlers at Delcambre, Louisiana, on Route 14.

Delcambre is home of the Shrimp Festival, the third full week in August (*BH* 125).

Leaning barn under a live oak at the edge of Bell City, Louisiana, on Route 14. *(Right)*

From New Iberia to Lake Charles, Heat-Moon drove across southern Louisiana on Route 14, which parallels the Gulf coast about thirty miles south. He then turned north, passing through Zwolle on his way to Shreveport, and headed west into Texas (*BH* 125).

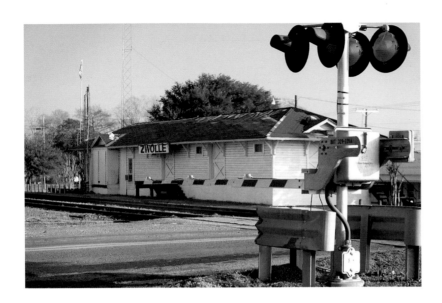

Train station, Zwolle, Louisiana, off US 171.

Heat-Moon pointed out the odd coincidence that Zwolle, alphabetically, is the last town in the Rand-McNally *Road Atlas* and Abbeville, a town less than two hundred miles to the southeast, is the first (*BH* 125).

Sabine River just northeast of Carthage, Texas, US 79.

Taking US 79 west out of Shreveport, Louisiana, Heat-Moon began a gradual southwest course across nine hundred miles of Texas. West of the Sabine River, "the land became hilly and green with deciduous trees and open in a way Louisiana was not" (*BH* 132).

Four—South by Southwest

Texas

The Caddoan Mounds State Historical Site, southwest of Alto, Texas, on Texas 21.

The earthen mounds served as ceremonial sites for the Caddoan peoples living here between 1000 B.C. and A.D. 1550. Heat-Moon mused about his being "a resident from the age of lunch meat, no-lead, and Ziploc bags—sitting on a thousand-year old civic center" (*BH* 133).

The city symbol in Dime Box, Texas, Route 141.

Texas 21, the Old San Antonio Trail, passes through Old Dime Box, which today is just a couple of buildings. New Dime Box on Route 141 was founded in 1913 to be on the recently built railroad. Heat-Moon describes the second Dime Box as "an M-G-M backlot set for a western" (*BH* 134–36). Except for a recent bank and a few stores, that's still appropriate.

His lunch stop—Ovcarik's Cafe, which touted four calendars in 1978—has been closed for some time. The building was moved from the main street to a place along the tracks and now houses the Dime Box Community Center. The bar where he met several local residents, Sonny's Place, went out of business about 1985.

The sign (right), built after Heat-Moon's visit, advertises the Dime Box State Bank. The town got its name early, because citizens would drop ten cents along with a letter into the pickup box.

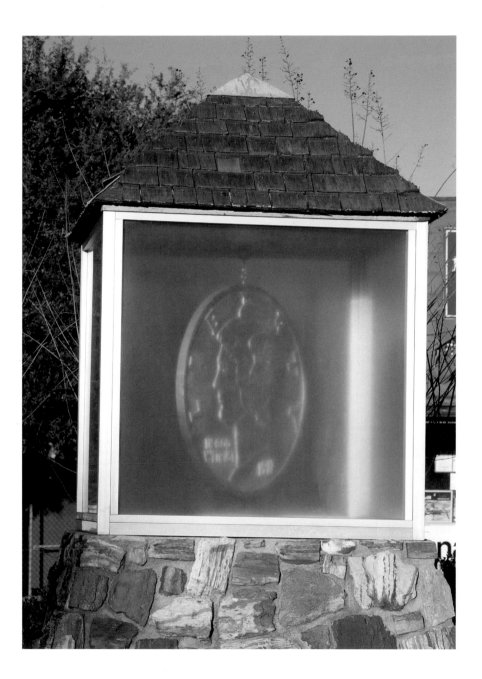

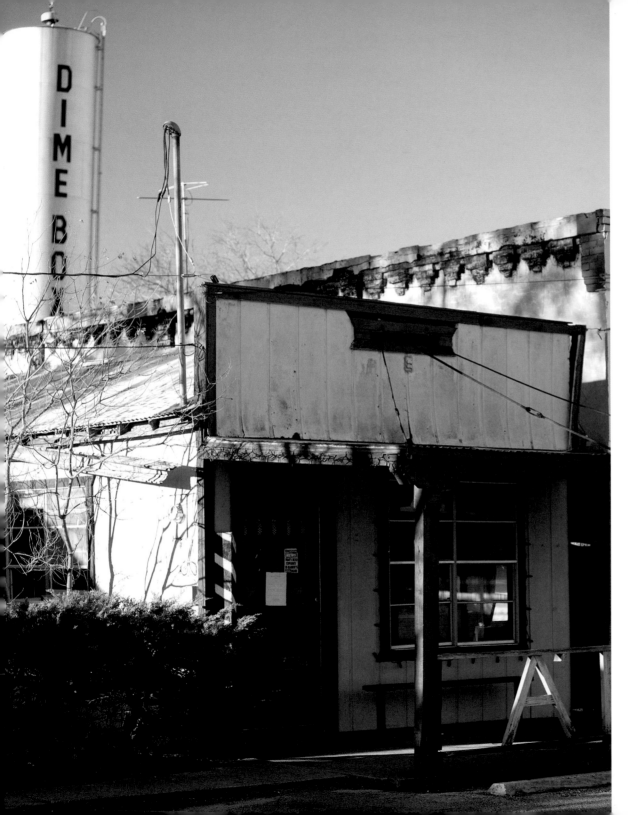

Barbershop in Dime Box, Texas, on Route 141.

While photographing the barbershop, I met Larry Lehmann, a businessman and the fire chief, and for me, the city historian. The barbershop still operates. Unfortunately, it was closed the Friday afternoon I visited Dime Box, and my peek through the window didn't reveal whether the Texas bull-bass was still hanging on the wall (*BH* 137). On the door was taped a headline from the *Weekly World News*—"Man's Head Explodes in Barber's Chair—story and photo inside."

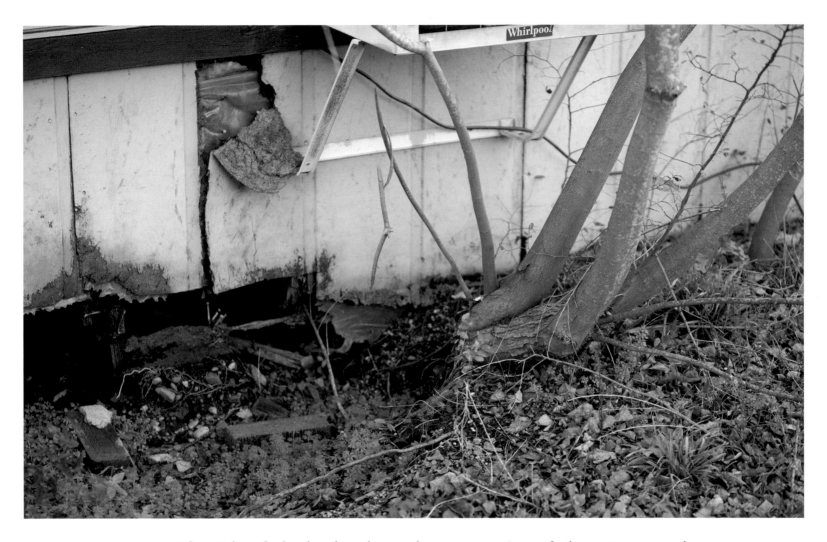

The side of the barbershop where a portion of the cottonwood tree still grows, Dime Box, Texas, on Route 141.

During Heat-Moon's $1.50 haircut, the barber took him out of the chair to the window to show him a cottonwood tree he had cut down annually for six years. The tree, just under the edge of the building, was lifting the floor (*BH* 139). It was still growing adjacent to the building near the damage when I visited, almost twenty-nine years later. Claud Tyler, the barber, died before Heat-Moon's book was published in late 1982.

Nimitz Hotel, Fredericksburg, Texas, US 290 and US 87.

Built in 1880 by Charles H. Nimitz, the hotel was constructed to look like the prow of a steamboat. Charles was the grandfather of Chester Nimitz, the commander of the Pacific Fleet in World War II. Heat-Moon points out that it "was no wonder Chester, in his first command at sea, ran his destroyer aground and got court-martialed; that was natural for a boy who grew up steering a hotel across the prairie" (*BH* 143–44).

Main Street, Fredericksburg, Texas, US 290 and US 87.

The German immigrants who designed Main Street made it wide enough to turn around an ox cart. Heat-Moon wrote, "It was so broad, I had to make a point of remembering why I was crossing to keep from forgetting by the time I reached the other side" (*BH* 144).

Otto Kolmeier Hardware Building, Fredericksburg, Texas, US 290 and US 87.

The store still has the original "wooden floor and shelves requiring a trolley ladder" (*BH* 144). Upstairs you'll find wooden bins for nuts and bolts and under the stairs a metal box labeled horseshoes. A linens shop now occupies the first floor.

Main Street's white elephant, Fredericksburg, Texas, US 290 and US 87.

Heat-Moon explains that "albino elephants were once symbols of hospitality, but it had been years since you could buy a drink at the White Elephant." The building was a German import boutique when he visited Fredericksburg (*BH* 145).

West of Eldorado, Texas, US 190.

For eighty miles west of Eldorado along US 190 there is still no town, and the road is still "straight as a chief's countenance" (*BH* 148).

Broad Mesa on US 190, formerly Texas 29.

Heat-Moon wrote of people saying, when describing this stretch of road, "There's nothing out there." He compiled a list of thirty items, "of nothing in particular," and added, "To say nothing is out here is incorrect; to say the desert is stingy with everything except space and light, stone and earth is closer to the truth" (*BH* 149–50).

Just west of the Pecos River, Texas, US 190. (Left)

"A strangely truncated cone" appeared to Heat-Moon to be a Mayan temple arising from the desert floor (*BH* 150).

Prickly pear cactus and snow, near Eagle Flat, Texas, just off Interstate 10.

Near this place, Heat-Moon stopped to admire the beauty of the desert, hidden from many travelers because of their rapid transit through a land they assume contains "nothing" (*BH* 152).

The lights of Las Cruces, New Mexico, just off Interstate 10.

Heat-Moon drove through El Paso and out of Texas into New Mexico. Just south of Las Cruces, he crossed the Rio Grande River, and as he gazed back eastward, he saw the "shattered Organ Mountains" looming above the city. Farther east, beyond the mountains, lay the White Sands country of New Mexico (*BH* 153).

West of Las Cruces, New Mexico, Interstate 10.

"A land of tourist trading posts where yellow and black billboards repeated like a stutter" (*BH* 153). Thirty years later, the yellow-and-black signs still pitch copper jewelry, cactus jelly, and candy. (And Exxon might change its sign: pay through the nose rather than pay at the pump.)

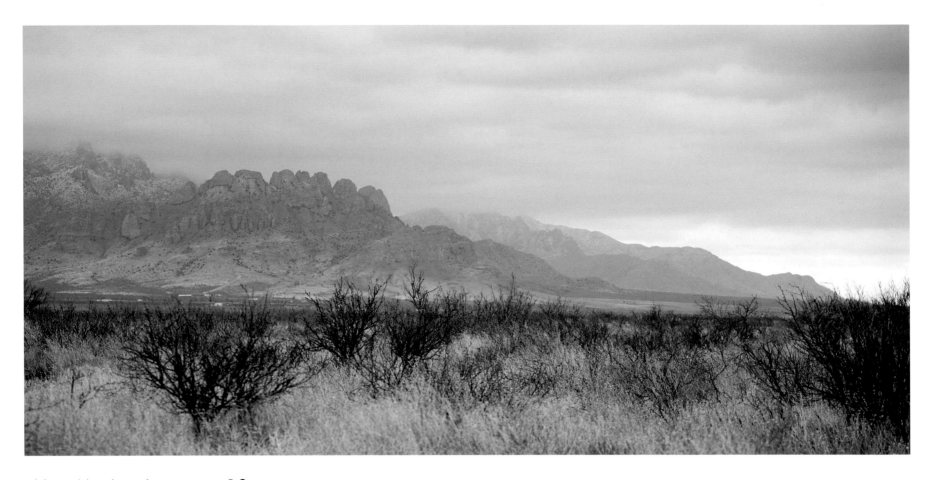

New Mexico, Interstate 10.

"Treacherous jags tearing into the soft bellies of clouds." Heat-Moon's description of the Floridas (Flo-RHY-duhs) Mountains looking south from I-10 says it all. He saw no roads, high-tension power lines, parabolic dish antennas, or concrete initials of desert towns—just "mountains to put man in his place" (*BH* 153). Today a road and a few buildings encroach on the mountain.

The Manhattan Cafe, now the Si Señor Restaurant in Deming, New Mexico, just off Interstate 10.

Heat-Moon ate dinner at the Manhattan Cafe: tortillas, huevos rancheros, and a green pyrotechnic salsa. "Gritty as a lizard," he "went looking for a bath and found a room" for eight dollars at a motel near the edge of town (*BH* 154)—the first of only three nights he paid for lodging during his three months on the road.

Looking west from New Mexico Route 146, north of Hachita.

It's hard to imagine how a coffee mill could change this scene; but if you look carefully, its effect is visible— there's a fence. Heat-Moon observed how "a handcrank coffee mill helped kill off the Old West." Joseph Glidden, of Illinois, first made barbed wire fence in 1874 using a "converted coffee mill." From that point forward, "the cowboy was on his way to becoming a feedlot attendant" (*BH* 155–56).

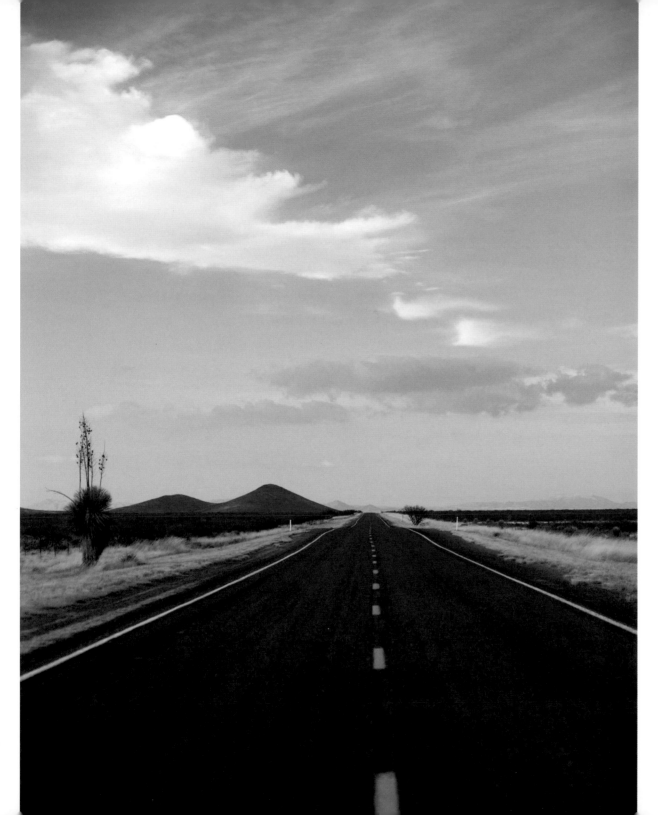

New Mexico Route 146, north of Hachita.

In 1978 when Heat-Moon headed down this road, it was still New Mexico 81 and passed through open range—"a thing disappearing faster than the condor" (*BH* 155–56). The road is now lined with fence on both sides.

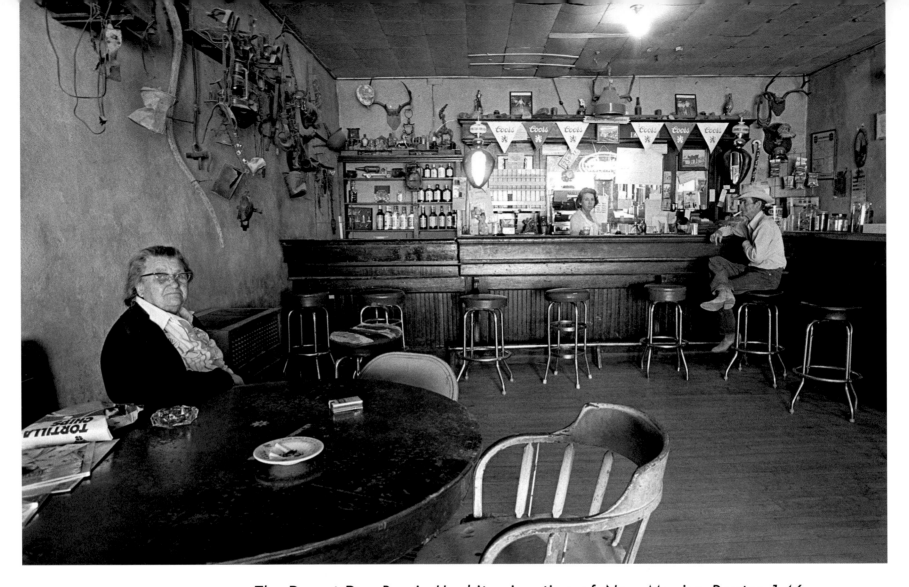

The Desert Den Bar in Hachita, junction of New Mexico Routes 146 and 9. Iva Sander (Virginia's mother), Virginia Been (behind the bar), and customer (photograph by Heat-Moon, 1978).

Knowing he'd found an authentic western saloon Heat-Moon wrote, "The ichthyologist who first found the 'fossil fish' coelacanth still swimming the seas could have had no finer pleasure than I did in coming across a buttressed adobe saloon that by all right should have been extinct" (*BH* 157).

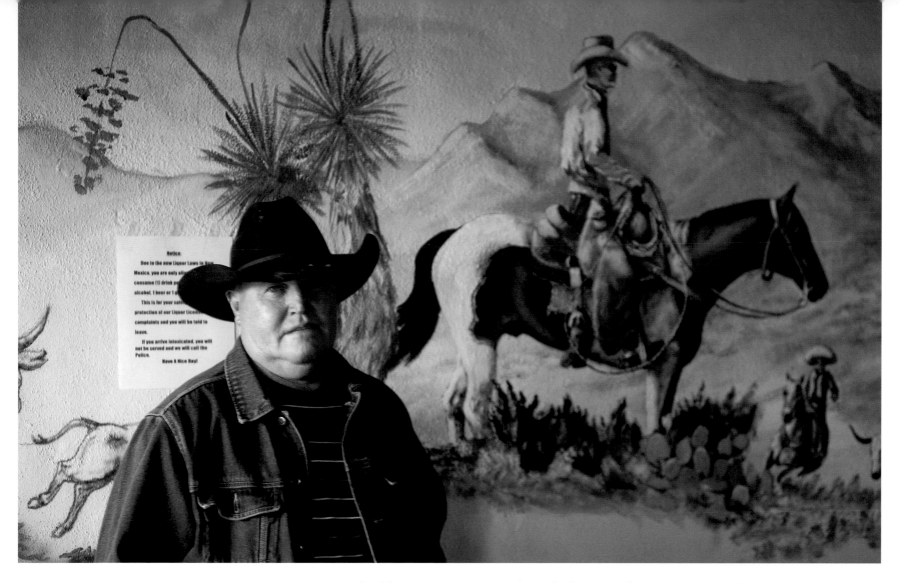

L.C. May, current owner of the Hachita Liquor Saloon—once the Desert Den Bar—in Hachita, junction of New Mexico Routes 146 and 9.

L.C. stands in front of a mural of his father, on the wall just behind where Iva Sander sat in the 1978 photograph (*BH* 157–60). He's thinking about putting the saloon up for sale.

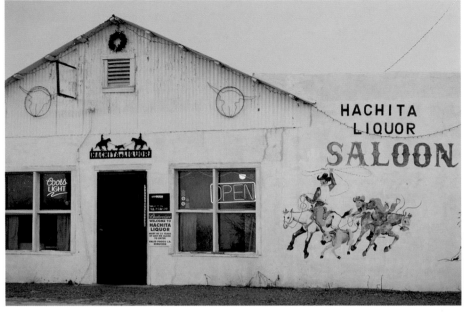

The former Desert Den Bar, Hachita, junction of New Mexico Routes 146 and 9.

The bar counter used to be against the back wall shown in the photograph on the left. It was moved to the right wall just inside the entrance to make room for a pool table. In 1978 Virginia Been told Heat-Moon, "We've always guaranteed one thing—this is the best bar in town. Anybody doesn't like it can drive fifty miles to the next one" (*BH* 157).

At the base of the Little Hatchet Mountains, New Mexico Route 9.

On this stretch of blue highway, Heat-Moon stopped to walk, listen to the silence, and ponder the desert. "There's something about the desert that doesn't like man, something that mocks his nesting instinct and makes his constructions look feeble and temporary. Yet it's just that in-hospitableness that endears the arid rockiness, the places pointy and poisonous, to men looking for its discipline" (*BH* 160).

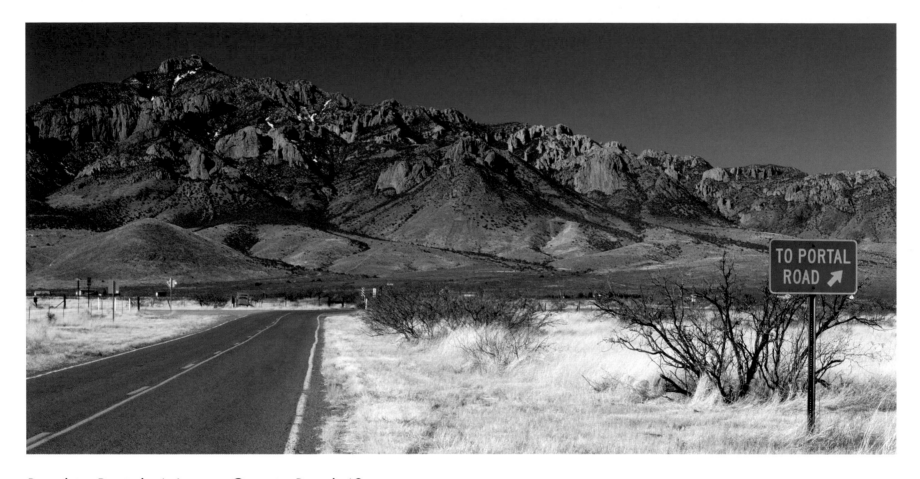

Road to Portal, Arizona, County Road 42, at the base of the Chiricahua Mountains.

The *Blue Highways* course through New Mexico traversed only the extreme southwest corner of the state (*BH* 161). New Mexico 9 dead-ends at Route 80. Three miles south is the Portal Road, a quiet entry point into Arizona.

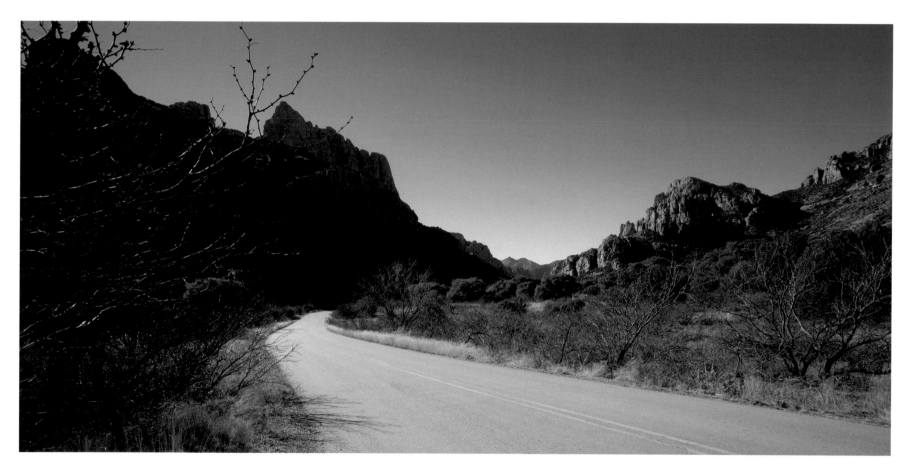

Road into Cave Creek Canyon, approaching the Chiricahua Mountains, Arizona, County Road 42.

Each evening I studied the *Blue Highways* account of the area I was to travel the next day. Going down this road, as was so often the case, I immediately recognized Heat-Moon's graphic description of driving around a curve and finding the "deep rift in the vertical face" of what had previously appeared to be an insurmountable wall—the Chiricahuas (*BH* 161).

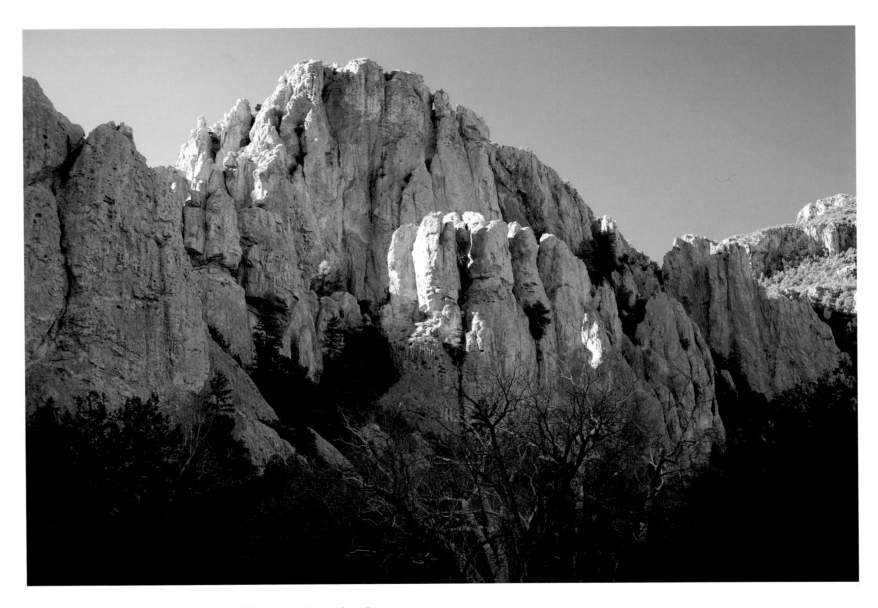

The Chiricahuas, Arizona, County Road 42.

The text painted the scene above me: "Canyon walls of yellow and orange pinnacles and turrets, fluted and twisted" (*BH* 161).

Cave Creek, Arizona, beside County Road 42.

It was beside this stream that Heat-Moon stopped for the night and hoped to "wash away the high-way wearies." Instead, he met a divorced Tucson banker, age forty-something, who "had so lost belief in a world outside himself that, without crisis, he had nothing worth talking about" (*BH* 162–66).

Onion Saddle, or Pinery Canyon Road, Arizona. *(Left)*

These are both names for portions of County Road 42, the still unpaved lane—but less rutted and now widened—that precariously crosses over the Chiricahua Mountains. Heat-Moon found the road filled with craters, ruts, rocks, hairpin turns, and no signs to guide his way. He decided, "he could only trust in the blue-highway maxim: 'I can't take it anymore' comes just before 'I don't give a damn.' Let the caring snap, let it break all to hell. Caring breaks before the man if he can only wait it out" (*BH* 167).

Chiricahua National Monument, Arizona Route 181.

When I hiked down a trail and saw this scene, I understood Heat-Moon's words, "I was in one of the strangest pieces of topography I'd ever seen, a place, until now, completely beyond my imaginings" (*BH* 162).

Arizona Route 186.

Driving out of the mountains onto Route 186, Heat-Moon looked in the van's rearview mirror and saw "the powdery visage of a man embraced by the desert; I was wearing a layer of the Chiricahuas" (*BH* 168). I, too, carried part of the Onion Saddle Road—mostly a thick, tenacious layer of mud on my boots, floorboard, snow tires, and undercarriage. I heard my snow tires slinging mud—flap, flap—for several miles of Arizona 186.

Arizona Route 186.

Still a crooked highway that dips into "arroyos rather than bridging them" (*BH* 168).

Arizona, Interstate 10.

"Wacky Texas Canyon, an abrupt and peculiar piling of boulders." Briefly traveling I-10, Heat-Moon was able to relax and reflect on the Tucson banker from the night before—"An empty man full of himself?" He continued, "after traveling nineteenth-century America, [Alexis] de Tocqueville came to believe one result of democracy was a concentration of each man's attention upon himself" (*BH* 168).

Arizona

Saguaro National Park, east of Tucson, Arizona, off Interstate 10.

"I don't suppose that saguaros mean to give comic relief to the otherwise solemn face of the desert, but they do. Standing on the friable slopes they are quite persnickety about, saguaros mimic men as they salute, bow, dance, raise arms to wave, and grin with faces carved in by woodpeckers" (*BH* 171). In this photograph, it's "flipping the bird."

Superstition Mountains, east of Phoenix, Arizona, on Route 87.

Indian lore held that people who entered the Superstitions would suffer a "diabolic possession" (*BH* 171). Early farmers in the Salt River valley, hearing these stories, gave the mountains their name.

Mogollon Rim, view from the edge, Arizona, on Route 260.

From this site, Heat-Moon could count nine ranges through the clear air. I took a photograph from the summit in the rain, with forty-mile-per-hour gusts. I returned later for this picture. The wind was still howling, but it wasn't raining. A close look at the full width of the image shows more than "nine mountain ranges, each successively grayer" (*BH* 172).

Storm brewing, north of Holbrook, Arizona, on Route 77.

Heat-Moon tells of a different storm here—the storm between the Navajo and the white settlers who drove them off the land "in retribution for their raids against whites and other Indians alike" (*BH* 173).

Red rock, Navajo Reservation north of Holbrook, Arizona, on Route 77.

The Navajo returned to the incomparable beauty of their homeland, which also contained coal, oil, gas, uranium, helium, and timber (*BH* 173–74). The Navajo Nation includes the northeast corner of Arizona and extends into Utah and New Mexico—over twenty-seven thousand square miles—and is larger than ten states.

Second Mesa, Hopi Reservation, Arizona, on Route 264.

"Like bony fingers, three mesas reached down from larger Black Mesa into the middle of Hopi land. . . . From the tops, the Hopi look out upon a thousand square miles" (*BH* 174–75). I visited First Mesa on a tribal holiday: dancing, singing, food, and children—no photographs allowed.

Echo Cliffs, Arizona, US 89.

After passing through the Navajo and Hopi Nations, Heat-Moon turned north toward Utah on US 89, which skirts the edge of the Painted Desert and runs along the base of the Echo Cliffs (*BH* 177).

Navajo Bridge, Arizona, Alternate US 89.

This is the New Navajo Bridge, which opened in 1994 to replace the old bridge built sixty-some years earlier. The earlier span still stands for use by pedestrians. Prior to the original bridge, a traveler had to cross the Colorado River via Lees Ferry, four miles upstream (*BH* 177).

Vermillion Cliffs, Arizona, Alternate US 89.

The *Blue Highways* route runs alongside this escarpment for almost thirty miles before ascending the Kaibab Plateau, "an enormous geologic upheaval [where] the small desert bushes changed to immense conifers" (*BH* 178), and one enters the southwest corner of Utah.

Aspen Mirror Lake, Utah Route 14.

Heat-Moon started over a mountain on Utah 14 on April 26 (*BH* 179). I traveled the same route on September 25. Both dates could mean high altitude mixed with a low pressure front might produce sleet and snow conditions. I learned from his book not to start the passage at dusk. Had it not been dark and an evening of nasty weather, Aspen Mirror Lake would surely have been one of his stops.

Utah Route 148 (formerly 143), two hundred yards off Utah Route 14.

Heat-Moon spent a long, frozen night, one of the most harrowing nights in *Blue Highways* in this location where the road disappeared "under a seven-foot snowbank." My travel over that road on a beautiful afternoon in late September was more pleasant. Stuck in the snowstorm, he imagined a headline: "Frozen Man Found in Avalanche" (*BH* 179–81).

Aspen, Utah Route 14.

The morning after the frozen night on the mountain, Heat-Moon passed right by this scene. The snow then was higher than the rail fence (*BH* 179).

Moonrise over the Hurricane Cliffs and Coal Creek, Utah Route 14.

This stream parallels Utah 14 through Cedar Canyon east of Cedar City, the road that Heat-Moon used to get off the snow- and sleet-covered mountain (*BH* 181).

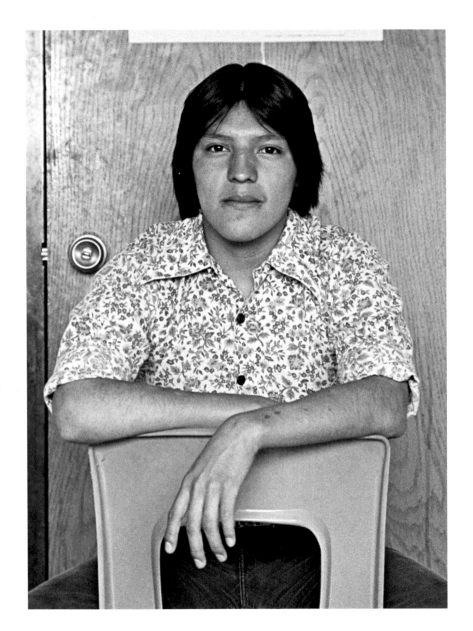

Kendrick Fritz, student at Southern Utah State College in Cedar City, Utah Route 56 (photograph by Heat-Moon, 1978).

After spending the night in hail and snow, Heat-Moon made his way down the western slope of the mountain to Cedar City. He stopped at Southern Utah State College to eat breakfast in the cafeteria. It was there he met Kendrick Fritz, a Hopi, studying chemistry with plans to go into medicine.

Heat-Moon asked Fritz if it would be difficult to carry his Hopi heritage into a world as technological as medicine.

Kendrick answered, "Heritage? My heritage is the Hopi way, and that's a way of the spirit. Spirit can go anywhere. In fact, it has to go places so it can change and emerge like in the migrations. That's the whole idea. . . . To me, being Indian means being responsible to my people. Helping with the best tools. Who invented penicillin doesn't matter" (*BH* 181–87).

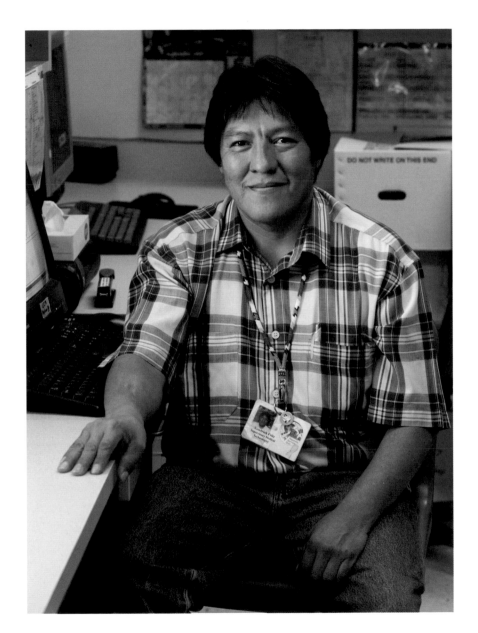

Kendrick Fritz, Kayenta, Arizona, 2007.

After a year at Southern Utah State College, Fritz spent a semester at the University of Arizona. Then he joined the US Navy for six years where he worked in medical technology. After the service, he spent one year with his family planting crops and then returned to school at Weber State University to get a degree in medical technology.

His spirit has indeed gone places, even migrating back to Kayenta, Arizona, where he is the laboratory supervisor at the Indian Health Service Hospital and Clinics—being responsible to his people with the best tools of modern medicine. Kendrick's wife is Navajo, and they have six children, four girls and two boys.

Sagebrush Flats, Escalante Desert, near Modena, Utah, on Route 56.

While crossing the seemingly endless sagebrush flats, Heat-Moon noted a man taking photos from his moving car. He was thinking how absurd that was, and then he realized: "I, too, was rolling effortlessly along, turning the windshield into a movie screen in which I, the viewer, did the moving while the subject held still. That was the temptation of the American highway, of the American vacation (from the Latin *vacare*, 'to be empty')" (*BH* 188).

Cathedral Gorge, Nevada, US 93.

Only twenty miles from the Utah/Nevada line, the route turns north on US 93. Heat-Moon described it as "an empty highway running from Canada nearly to Mexico. . . . It must have fewer towns per mile than any other federal highway in the country" (*BH* 188). He found seventeen towns along its five-hundred-mile course through Nevada. Thirty years later, I counted only fourteen. North on US 93 are several turnoffs to Cathedral Gorge. A million years ago this was a lake bed, but centuries of erosion of the bentonite clay resulted in these spectacular formations.

Stokes Castle, Austin, Nevada, US 50.

While Heat-Moon was at Clara's Golden Club, a man suggested he take a look at the castle out on the mountain edge. "Everything's falling down now, but you can get an idea of the money we used to have here" (*BH* 194–95). Built in 1896–1897 and occupied by the Stokes family for only one brief period in 1897, it has been uninhabited ever since. The architectural model for the castle was a medieval tower Anson Stokes had seen and admired in the Italian countryside near Rome. It still has a commanding view of the Reese River Valley to the west.

Setting moon over the Clan Alpine Mountains, Nevada, from US 50.

Heat-Moon observed that "highway 50 is one archaeological layer of communication upon another." The trail it follows was used by Indians, Forty-Niners, stagecoaches, the Pony Express, and it was "the route of the first transcontinental telegraph" (*BH* 197).

Populas deltoides pedes, *near Eastgate, Nevada, off US 50.*

This newly discovered subspecies of the cottonwood is known to produce hundreds of shoe-like pods in a variety of shapes, sizes, and colors. It bears fruit best if located near teenagers. The Clan Alpine Mountains are in the distance.

I got bombed at Frenchman.

In September 2007, as I followed Heat-Moon's route in western Nevada on Highway 50, I found where Frenchman, Nevada, had once been. There were no buildings—only a few pipes rising from the ground. Examining the Frenchman photograph in *Blue Highways* confirmed I had found the right spot—a large gravel parking area, the shape of the distant mountains, the angle of US 50. The pieces of the puzzle fit. But I was unable to locate any members of the Chealander family. Fallon and Reno directory assistance produced several leads, but none of them got me to the Chealanders.

While I was eating lunch at the Frenchman site and pondering how to track down the Chealanders, two Navy fighters began to drop practice bombs just a mile or so away. In 1978 Heat-Moon was told about a plane that dropped a bomb on Highway 50, the year before, "and nearly killed some clown in a car." The dummy bomb "just bounced up on the pavement and rolled dead" (*BH* 199). I saw the reality of that bar story graphically reinforced. The Chealanders used to sell hats and T-shirts with the engraving, "I got bombed at Frenchman." I had just joined the club.

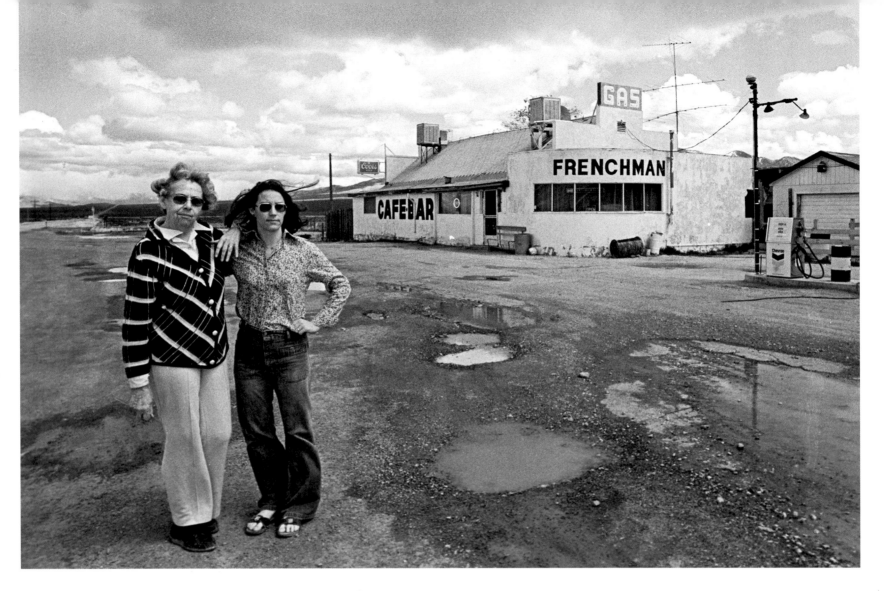

Margaret and Laurie Chealander in Frenchman,
Nevada, US 50 (photograph by Heat-Moon, 1978).

When Heat-Moon stopped in Frenchman, the settlement consisted of a cafe-bar-motel-gas station-home with a population of four: Laurie and her husband, Chris; their two-year-old daughter, Callie and Chris' mother, Margaret (*BH* 197–203).

Laurie Chealander between two of her three daughters and a grandson in Frenchman, Nevada, US 50, 2009.

Meshing five busy schedules was not easy. Callie and her son, Sean (to the right in the photograph), flew in from the Midwest the day before. Camille, to the left, had to be at work by early evening; and Caren (who is in nursing school and not in the photograph) had an exam. They stand close to the same location shown in Heat-Moon's photograph. The buildings are gone, removed by the US Navy after it purchased the property in 1986.

I didn't find the Chealanders on my 2007 trip through Frenchman, but in 2009 I sent a letter to all eight addresses I had accumulated for Laurie. One of the letters found her. I flew to Reno to photograph her and talk about the last thirty years.

The family, including her hardworking mother-in-law, Margaret, lived at Frenchman eight more years after Heat-Moon's visit. During that time, Caren was born in 1979 and Camille in 1983.

I said to Laurie, "You told Heat-Moon you considered delivering your firstborn, Callie, on the pool table. Was the pool table used for either Caren or Camille?"

"No, we didn't have the pool table when Caren was born. I had just worked about sixteen to seventeen hours. My back was hurting—I had been in labor all day and didn't know it. It was hunting season and I was just way too busy. My water broke, and twenty-five minutes later Caren became the only person known to have been born in Frenchman, Nevada"—on or off a pool table. Chris tied off the umbilical cord with a boiled shoelace and cut the cord with a pair of vegetable shears.

After the Navy bought up all of Frenchman in 1986, the family moved to Fallon, Nevada. Laurie applied to work for the county road department. "When I went to interview, talking with the supervisor, he said, 'Laurie, we can't hire you—you're a woman.' I said, 'You can't say that.' He said, 'Well, this is Fallon, and we can do pretty much what we want.'"

Laurie sued for sexual discrimination, settled out of court, and was then given a job as the janitor for Churchill County. "It was horrible—seven buildings—one person—the museum, the library, sheriff's department, road department."

Two and a half years later she found work as a janitor at Western Nevada Community College in Fallon.

"That's when I decided, I've got to go to school. I can't do this janitor stuff forever." She enrolled at the college and finished her associate degree while working full-time as the janitor. She went on to the University of Nevada at Reno and got her bachelor's degree in social work. She was hired, on graduating, but decided she wanted to be a therapist. For two years she drove 404 miles a day to Sacramento State to complete her master's degree. "Caren graduated from high school in 1998, and I graduated from Sacramento State." Laurie now works as a mental health therapist and loves her work.

I asked her how appearing in *Blue Highways* affected her life.

"We had so many people taking the *Blue Highways* route, and they would have each person in the book sign it.

That was fun. It went on for a few years when we were working with the Navy to try and sell the place because of the bombs and flyovers. I think we were ready for a change. I had been out there twelve years with a cathouse on one side and the [Navy bombing run] gate on the other. I think it was in 1986 that a cathouse map came out, and we were on it. People would stop in, mainly truck drivers, and say, 'We're looking for Bombshell Betty's.'

And I would say, 'I have no idea where that is.' They'd ask, 'Where are the girls?'"

At first, Laurie thought the men were asking about her daughters.

"One day a truck driver came in and brings in one of those maps, and it says, 'Frenchman Station—Bombshell Betty's.' I thought, oh my God, what would my grandmother say if she sees this? We went to our attorney to try and stop the maps, but it was an out-of-state dummy corporation. I said, 'We can't stop it . . . what am I going to do?'" The purchase of Frenchman by the US Navy solved that problem.

Laurie and Chris divorced in 2002. Margaret, then age seventy-one, continued to work long days right up to the purchase of Frenchman by the Navy. She lived with Chris, Laurie, and the three girls a number of years before moving into a retirement community in Fallon. Margaret died in October 2005 at age ninety.

I asked Laurie if she missed Frenchman.

She said. "Sometimes I think I miss the independence of doing what you want. There were no wages. A generator twenty-four hours a day. I don't miss it. It was hard work—work for a younger person."

Sand Mountain, seven miles west of Frenchman, Nevada, US 50.

In Frenchman, Heat-Moon met several regulars in the cafe—each identified by what he drank or ate. A geologist had an egg and a slice of lemon pie; another man, vodka and root beer; and a miner, Beam on the rocks. The men argued incomprehensibly over whether Sand Mountain had changed sides of the road. As he headed west through Reno and into northern California, Heat-Moon realized that Sand Mountain was actually windblown sand—it could move (*BH* 200–203).

Maxi's, Salt Wells, Nevada, US 50.

Heat-Moon stopped at Maxi's, a brightly painted Chinese-red tavern, which turned out to be a cathouse conveniently located on US 50. At the bar he was greeted by Tiffany, "one of the most facially unfavored women I'd ever seen. . . . She was a good dose of saltpeter." Wanting only to have a beer, he repeatedly fended off Tiffany's advances. "That woman must have been a terrific salesperson. She had backed me into a dialectical corner with three or four sentences and left me only two escapes: admit to deviance or prove a capacity to perform at her standard. . . . The woman had the tactical mind of Patton. She blocked me at every move" (*BH* 203–5). Apparently, things got *too* hot in Maxi's one night. This pile of charred rubble is all that's left.

The Truckee River flowing beside Interstate 80 east of Reno, Nevada.

After the bartender at Maxi's explained to Heat-Moon that Tiffany had cured "worse cases" than his, he quickly finished his beer and took his "case" west on US 50. He passed through Fallon and took Alternate US 50/US 95 to Interstate 80 that follows the Truckee River toward Reno (*BH* 205).

Humbug Creek, Portola, California, on Route 70.

Thinking about recent humbug in his life, Heat-Moon was surprised at the appropriateness of the creek name (*BH* 206).

Lake Almanor, California, on Route 89.

Highway 89 follows a curving northwesterly route through the Plumas National Forest—beside multiple streams and eventually Lake Almanor, formed by Canyon Dam on the North Fork of the Feather River (*BH* 207).

Lassen Volcanic National Park, California, on Route 89.

Heat-Moon continued north on California 89 ascending into the park only to find a "road closed" sign halfway up the mountain. As night fell, he had to go back down the mountain and around its western edge in the dark. He was soon surrounded by "thunder eggs"—huge rocks ejected years ago by the volcano—on a road consisting of two "troughs" that was so narrow the tree limbs scratched at both sides of his van (*BH* 207–8).

The weather allowed me to follow California 89 north through the park. The road serpentined around Lassen Peak on three sides and offered access to multiple trails, lakes, streams, and geothermal pools.

Lassen Volcanic National Park, California, on Route 89.

From this vantage point above Lake Helen, three peaks are visible (from left to right): Brokeoff Mountain, Mount Diller, and Pilot Pinnacle. Mount Lassen lies right of these peaks. Heat-Moon parked overnight in a state campground just north of here. The rain was "drubbing hard," he was too tired to eat, and he realized he was sleeping "under a volcano that had exploded within living memory" (*BH* 209).

Hat Creek, California, on Route 89.

It was just after bathing in this ice-cold stream and toweling off that Heat-Moon saw a camper pull in. Shortly thereafter he was approached by a nearly blind Pekinese dog named Bill, and then by its owner, a man in cowboy boots with a mane of white hair and a "face so gullied even the Soil Conservation Commission couldn't have reclaimed it." But Heat-Moon could still see mischief in the man's eyes.

As the old man related stories, every several minutes his wife—"a finger-wagging woman, full of injunctions for man and beast"—would stick her head out of their camper and rattle off instructions for either her husband or the dog. Each time he would respond under his breath, "Well, boys, there you have it" (*BH* 209–12). It's become our family's favorite phrase after an encounter with any individual who has a knack for accentuating the negative.

Mt. Shasta from California Route 89.

Sixty-eight miles north of Lassen Volcanic National Park, Route 89 intersects with Route 299, where Heat-Moon turned right and headed northeast. I followed that road but was not able to see Shasta from the lookout area he described (*BH* 216)—cloud cover once again thwarted my view. The next day I reversed course and went farther up Highway 89 to get this view. Returning to the *Blue Highways* path, California Routes 299 and 139 took me into southern Oregon.

View southwest from Mt. Mazama, just miles off Oregon Route 62.

From here, one can see the Rogue River National Forest and the valley the *Blue Highways* route passed through (*BH* 218).

Crater Lake and Wizard Island on Mt. Mazama, just miles off Oregon Route 62.

It is estimated that this 8,159-foot mountain had a height of 15,000 feet prior to the cataclysmic event only a few thousand years ago that created Crater Lake, undoubtedly one of the most beautiful lakes in the world. Here, we gain perhaps some insight into Heat-Moon's propensity to jump into bodies of cold water. He wrote that "Klamath braves used to test their courage by climbing down the treacherous scree inside the caldera; if they survived, they bathed in the cold water of the volcano and renewed themselves" (*BH* 218). It might be genetic?

Rogue River, Oregon, on Route 230. *(Left)*

The Rogue River just downstream from the entry of Muir Creek where Heat-Moon washed up. He found it to be "merely bracing," compared to Hat Creek whose waters come down ten thousand feet from Mount Lassen (*BH* 218).

Salt Creek Falls, Oregon Route 58.

At 286 feet, Salt Creek Falls is the second highest falls in Oregon. Beside Salt Creek, Heat-Moon read about the Lakota concept of "the good red road"—as opposed to the "blue road," the path of one "who lives for himself rather than for his people" (*BH* 219). This is the key idea in *Blue Highways* and the original significance of the title, a description that has now entered the American lexicon as a term for "back roads."

Bridge over Yaquina Bay, Newport, Oregon, US 101.

Had Heat-Moon been with me as I approached Yaquina Bay, he could not have described the view more accurately than he did almost thirty years earlier— "the blue Pacific shot silver all the way to the horizon" (*BH* 222).

Yaquina Head Light, Oregon, US 101.

About the coast, Heat-Moon wrote, "The cold waves, coming unimpeded from Japan six thousand miles away, struck the rocks hard, and the high surf so struggled, it looked as if the sea were trying either to get out or pull the shore back in" (*BH* 222).

Depoe Bay, Oregon, US 101.

Even in 1978 Heat-Moon noted that the fishing fleet was gone, and sport fishing and the tourist were the big catch. That hasn't changed. He ate at the restaurant where, "as if suspended above the harbor, it sat on the cliff with all comings and goings of men and boats" (*BH* 222–23). It's the gray building to the right of the bridge, the Spouting Horn Restaurant and Lounge, established in 1934.

Oregon coast from Neahkahnie Mountain, US 101.

The view from Neahkahnie Mountain "seemed to reach the length of Oregon" (*BH* 225).

Beach Sunset, Lincoln City, Oregon, US 101.

Heat-Moon's night in Corvallis was marked by his struggle to find the strength to continue a long and meagerly funded trip. What a different scene from several days before, when he was trapped in Ghost Dancing by "the morose rain" to watch "petals slip wetly down the windows" (*BH* 220). His days on the Oregon coast helped dispel any doubts that lingered.

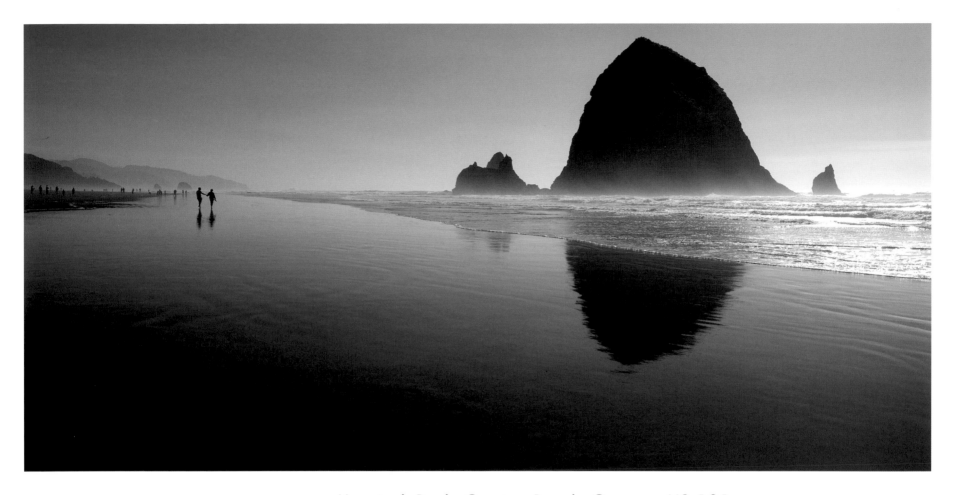

Haystack Rock, Cannon Beach, Oregon, US 101.

Where Heat-Moon saw "a three-hundred-foot domed skerry topped by a mantle of snowy bird stain, looking like a chipped whale's tooth" (*BH* 225). I saw unfathomable beauty. I was drawn to a palpable coastal energy that made *me*, for the opposite reason, reluctant to continue *my* journey.

Fort Clatsop's rough hewn furniture.

Heat-Moon comments that Lewis and Clark "celebrated the first American Christmas in the Northwest. Their dinner on that 'showery, wet, and disagreeable' Christmas, Clark said, was 'poor elk so much spoiled that we ate it through mere necessity, some spoiled pounded fish, and a few roots'" (*BH* 226). That Christmas was typical of their entire three and a half months at Fort Clatsop—cold, rainy, with only a limited food supply. On March 23, 1806, they gave the fort and furniture as a gift to Coboway, chief of the Clatsops, and headed east.

Fort Stevens, Oregon, on Ridge Road off US 101.

Fort Stevens was a US Army fort from the Civil War through World War II. On the night of June 21, 1942, a Japanese submarine fired on the fort—thereby earning, Heat-Moon says, "the distinction of being the last place in the forty-eight states attacked by a foreign power" (*BH* 224).

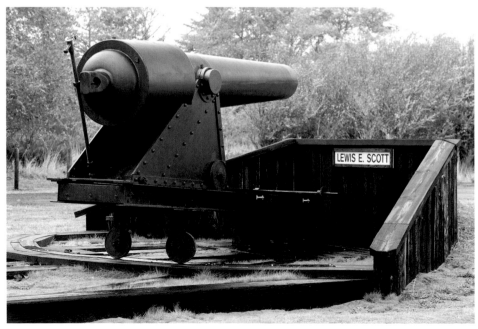

Fort Clatsop, Oregon, off US 101.

This is a reconstruction of what historians think the post looked like. A replica of the fort was first built in 1955. Much of the structure Heat-Moon saw was destroyed by fire in October 2005. By December 2006 this new replica was completed.

The Astoria-Megler Bridge over the Columbia River, Astoria, Oregon, junction of US 101 and US 30.

Heat-Moon passed this bridge in 1978 (*BH* 226) and then sailed under it seventeen years later on his "boat across America" voyage he describes in his third book, *River-Horse*.

Mt. Rainier south of Seattle, Washington.

On a "splendidly clear day," Heat-Moon rolled along US 30 east into St. Helens, Oregon. As he looked north and scanned to the east and then southeast, he could see Mt. Rainier, Mt. St. Helens, Mt. Adams across the Columbia River in Washington, and Mt. Hood to the southeast in Oregon (*BH* 227). On my visit to St. Helens, Oregon, the mountains were obscured by clouds, but on a later trip I took this photograph of Mt. Rainier, well north of the *Blue Highways* path.

Dan & Louis Oyster Bar, Old Town in Portland, Oregon, off US 30.

Of the restaurant established in 1907, Heat-Moon wrote, "[it] was one of those rare things in America: a restaurant serving the same menu in the same building on the same location for more than a generation" (*BH* 228).

From Portland he crossed to the north side of the Columbia River to take Washington Route 14 east, a route less traveled than either US 30 or I-84, both of which follow the southern bank of the river on the Oregon side.

Beacon Rock overlooking the Columbia River, Washington, on Route 14. (Right)

Heat-Moon describes Beacon Rock as "a monumental nine-hundred-foot fluted monolith of solidified lava" and points out that "Lewis and Clark camped here both going and returning" from the west coast (*BH* 230). It was especially significant to their expedition on the trip out because it marked the easternmost point on the Columbia River of measurable tides, an indication that the expedition was close to its goal, the Pacific.

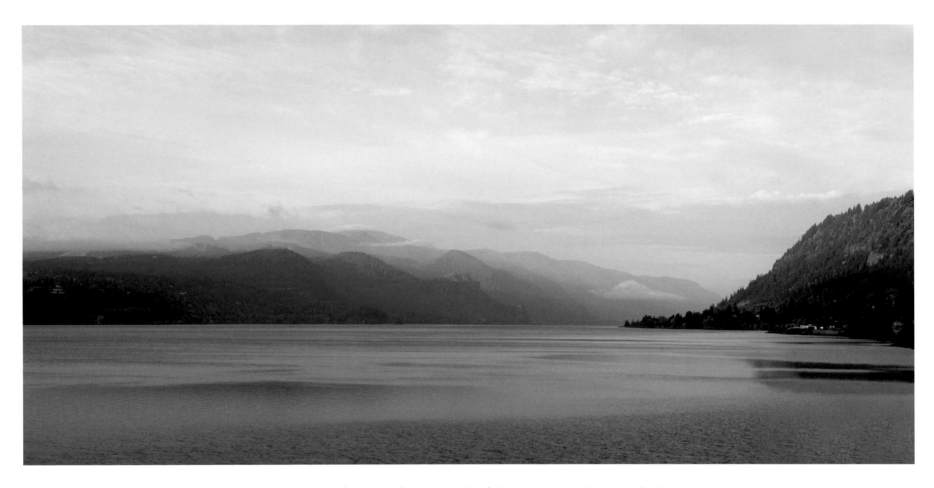

Columbia River, looking west near White Salmon, Washington, on Route 14.

This stretch of the river is between Bonneville Dam to the west and Dalles Dam upstream to the east. The *Blue Highways* route curves beside the Columbia on the north bank (right side in this picture) (*BH* 239).

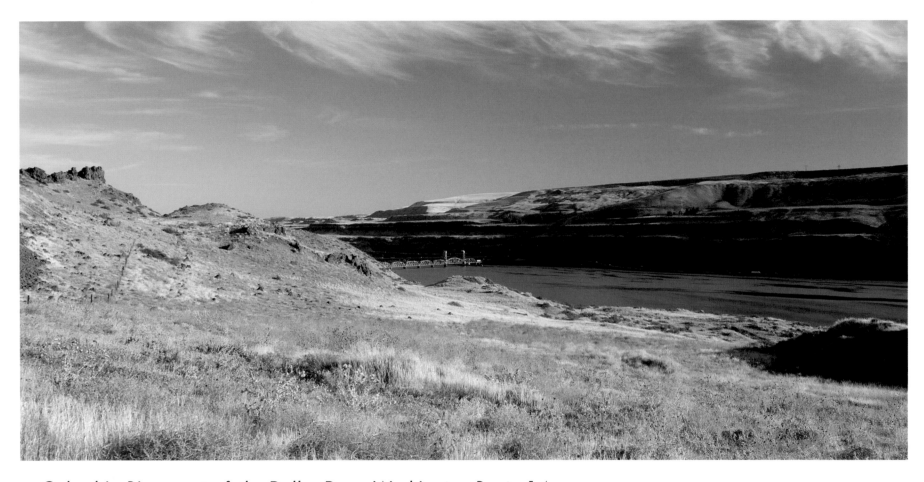

Columbia River east of the Dalles Dam, Washington Route 14.

It was in this territory where Heat-Moon noted nature had "drawn a north–south line forbidding green life: west, patches of forest; east, a desert of hills growing only shrubs and dry grasses" (*BH* 239).

Bob Holliston, Alba Bartholomew, and Garland Wyatt in the alfalfa field near Pitt, Washington, on Route 142 (photograph by Heat-Moon, 1978).

He found the men hang gliding from the mountain in the background down the Klickitat River valley a thousand feet below (*BH* 233–38). In 2007, Alba Bartholomew told me he continued to hang glide for another six years after meeting Heat-Moon—and with no major injury—but he quit when he began thinking he was "no lon-

ger bullet proof. Now, age fifty-seven I can't believe I did it. My last flight was on that hill where Heat-Moon took the original picture. I had flown downwind about two and a half miles and had a really nice landing—I never was very good at landing. That was the last flight I ever took."

Bob Holliston, Alba Bartholomew, and Garland Wyatt, 2007.

Bob Holliston graduated from hang gliders to building and racing planes. He was "points champion" two of the last six years in the R.A.C.E. Series and collected eighteen air-race trophies, which he displays on his "I love me wall." When I met him, he was building a plane he expects to go faster than 230 miles per hour. He stands next to the aircraft, which will require more than 2,500 hours to construct.

Bob Holliston told of an exciting flight to a race in Jean, Nevada. Flying at 17,500 feet and cruising at 270 mph with a "knockout tail wind," he kept smelling fuel. Angling the plane for better light, he saw a spray of fuel into the cockpit. Quickly turning off everything but the engine and a battery-operated GPS, he flew to the two closest airports, but both were socked in with fog. In desperation, he looked for a road to land on and spotted an abandoned airport with Xs at each end of the airfield. After he landed on the rock-studded runway, a man drove up wearing a security guard's uniform. The man said, "You know where you just landed? A prison!" He told Bob he was the second pilot to land there in ten years. After fixing the fuel line, Holliston, with the guard's help, cleared the rocks, and flew on to Jean. The next day, he won the race.

*The hang gliders' launch spot above the Klickitat
Valley, near Pitt, Washington, on Route 142.*

Garland Wyatt said most of his hang-gliding time was spent watching others. He made only two
flights—one off a cliff. When he got to the edge of the precipice and looked down, he really didn't
want to jump. He decided he would run toward the cliff and fake a stumble before he got near the
edge. But as he ran the wind lifted him anyway, and he was airborne in spite of himself. He sustained
no injuries on landing. He had paid $600 for his rig and sold it for $500: two glides at $50 per flight.

164

Stonehenge, Washington Route 14.

I found the monument near Maryhill, Washington, at about the same time of day as Heat-Moon. It was easy to capture what he had described thirty years prior. "The setting sun cast an unearthly light on the sixteen-foot megaliths" and Mt. Hood became a "black triangle" fifty miles to the west (*BH* 239)—visible through the orange haze to the right of Stonehenge in this photograph.

Trip Expenses

One of four gasoline credit cards Heat-Moon used on his journey.

He bought all but one tank of gasoline on credit cards from four different oil companies so he could spread the bills out. "I must here give credit to the Cherokee, my wife at the time, because over the three months I was gone, she was good enough to pay them until I returned. She could have left me to hang out to dry. You would think I would have planned for something like that."

He kept a log of his fuel use. "I was curious what the trip cost for gasoline. In 1978 gasoline averaged about seventy cents a gallon. The total over the almost fourteen-thousand miles was five-hundred-forty-three dollars and twenty-eight cents. That's about four cents a mile." He used 816.5 gallons. That's a bit over seventeen miles per gallon. I'm sure I got only two-thirds of that mileage with my V-10 engine.

Ledger of credit-card charges for gasoline compiled after the trip. *(Right)*

I asked, "Of the fifty-five gas stations you visited, is there one that stands out in your memory?"

He said, "The station at Paterson on Washington 14. I was certain I was going to run out of gas. I knew I was in the middle of nowhere, and it would be a long, long hike." A traveling salesman had once told him, "If you tense butt muscles tight enough, you can run on an empty tank for miles" (*BH* 243).

DATE	LOCATION	GAL	$	
20 MAR	COLUMBIA, MO	7.1	$4.00	
21 MAR	FAIRFIELD, IL	16.1	10.60	
23 MAR	HARRODSBURG, KY	16.2	11.00	
25 MAR	COOKEVILLE, TN	12-5?	8.00	
27 MAR	ELIZABETHTOWN, TN	16.1	9.50	
28 MAR	SILER CITY, NC	15.3	9.20	
30 MAR	PLYMOUTH, NC	14.4	8.90	
30 MAR	NEW BERN, NC	14-0?	9.00	
1 APR	RIDGEWAY, SC	16.4	11.15	
4 APR	McDONOUGH, GA	16.0	10.85	
6 APR	SELMA, AL	16.9	9.89	
7 APR	CLINTON, MS	14.1	9.60	
11 APR	SHREVEPORT, LA	13.7	8.75	
13 APR	NEW IBERIA, LA	16.	10.00	
14 APR	DE RIDDER, LA	16.5	11.00	
15 APR	SHREVEPORT, LA	8-00?	5.00	
18 APR	COLLEGE STATION, TX	15.7	8.60	
19 APR	MASON, TX	14.1	8.00	
19 APR	FORT STOCKTON, TX	14.3	9.00	
20 APR	FABENS, TX	16.9	10.86	
21 APR	DEMING, NM	9.5	6.00	
21 APR	TUCSON, AZ	16.1	10.00	
24 APR	PAYSON, AZ	10.9	8.50	
25 APR	TUBA CITY, AZ	14.6	10.50	
26 APR	HATCH, UT	16.2	11.20	
27 APR	CEDAR CITY, UT	9.4	6.00	
28 APR	ELY, NV	15.5	10.60	
29 APR	AUSTIN, NV	10.7	8.05	

DATE	LOCATION	GAL	$	
30 APR	QUINCY, CA	16-5?	11.75	
1 MAY	STRONGHOLD, CA (TULE)	17.9	*12.50	
2 MAY	HARRISBURG, OR	16.5	10.40	
5 MAY	CLATSKANI, OR	15.7	10.00	
7 MAY	PATTERSON, WA (DUMMER)	16.2	12.40	
9 MAY	COEUR D'ALENE, ID	16.2	11.50	
10 MAY	KALISPELL, MT	16.5	11.50	
11 MAY	CHESTER, MT	12.4	8.50	
12 MAY	POPLAR, MT	17.6	*12.50	
12 MAY	MOHALL, ND	16.2	10.90	
13 MAY	CAVALIER, ND	12-0?	8.90	
16 MAY	LAKE ITASCA, MN	5.3	3.50	
16 MAY	REMER, MN	15.1	10.40	
17 MAY	PARK FALLS, WI	16.4	11.50	
17 MAY	COPEMISH, MI	17.5	12.45	
20 MAY	BAD AXE, MI	14.3	9.30	
20 MAY	LEWISTON, NY	17.	11.50	
24 MAY	PORT BYRON, NY	15.5	11.00	
25 MAY	RENSAELAR, NY	14-5?	9.00	
29 MAY	W. LEBANON, NH	15.7	10.00	
2 JUN	NEEDHAM, MA	16.7	10.50	
6 JUN	QUOQUE, NY	16.5	12.05	
7 JUN	MAURICETOWN, NJ	16.7	11.00	
8 JUN	GLEN BURNIE, MD	17.2	11.00	
9 JUN	WASHINGTON, PA	*18.2	12.15	OIL*
9 JUN	RICHMOND, IN	16.3	11.18	
9 JUN	POCAHANTAS, IL	16.7	12.15	
→	TOTALS:		$543.28	

→ 4¢ per mile, 24 miles per dollar

Left Page

DATE	FOOD	GAS	OTHER
20	—	4.00	
21	—	10.00	
22	1.00	—	+$20.00 RM
23	### —	11.00	
24	4.00	—	
25	1.25	—	
26	1.45	8.00	
27	1.50	9.50	
28	5.25 GR	9.20	$16.70 Books/Tshirt/Batt.
29	1.00	—	
30	7.75	8.90	$2.15 Book/Pcs +$5.00 MK
31		9.00	
APR 1	1.60	11.15	
2	7.25	—	
3	7.40 GR	—	
FOOD 4	3.00	10.85	
/15.00 5	2.25	—	
6	—	9.20	
7	—	9.00	$3.00 Books
8	—	—	
9	—	—	+10.00 RGT
10	—	—	
11	2.25	8.25	
12		—	
13	20.80 →	10.00	$9.50 GR / 10.32 BAC
14		11.00	8.50 OIL FILTERS
15	2.00	5.00	3.40 OIL / 5.00 HEADLAMP
16		—	
17	3.50	—	7.90 CASE
18	3.85	8.60	
19	3.25	8.00	$1.80 AC/GIFT

Middle Page

$100.00 CASH

DATE	FOOD	GAS	OTHER
20	5.00	19.00	8.00 MOTEL
21	4.80 GR	10.00	+$70.00 RGT
22	2.50	6.00	
23	—	—	
24	3.25	8.50	12.00 CLTHS / 3.00 PHOTO
25		10.50	.90 BOOK
26	2.00	11.20	.50 POSTAGE
27	5.10 GR	6.00	2.50 BOOK/POSTAGE
28	5.25	10.60	
29	2.30	8.05	
30	1.40	11.25	.65 LAUNDRY
MAY 1	5.25 GR	12.50	
2	3.45	10.40	
3	1.50	—	5.00 MOVIES / 38.50 BOOKS SOPANO
4	6.00	—	
5	4.25	10.—	12.00 GIFTS / 5.00 MOVIES
6	—	—	
7	—	12.10	1.00 MUSEUM
8	—	—	
9	3.20 GR	11.50	$9.00 FILM / $10.00 AIR
10	3.20	11.50	
11	4.40	8.50	
12	2.20	23.40	$6.70 ROOM
13	4.90	11.00	$2.50 MOVIE
14	—		
15	3.25	—	4.50 AC
16	16.00 GR	13.90	
17	1.60	11.50	
18	.55	12.45	27.30 FERRY
19	5.50		1.20 BOOK / 14.50 SHIRT
20	2.35	9.20	20.80

Right Page

DATE	FOOD	GAS	OTHER
21	$3.00	—	
22	$7.00	—	
23		—	
24	—	11.00	+4.00 gas
25	$12.00 X	9.00	
26	20.80 X	—	+10.00
27	3.50 X	—	$15.00 GIFT
28	13.55 X	—	
29	4.00	10.00	8.00 BOOK / $9.00 SHIRT
30	—	—	
31	3.00	—	$1.50 GIFT
JUN 1	2.00	—	10.45 GIFTS
2	4.55 GR	10.50	52.00 SUPPLIES
3	—	—	
4	—	—	
5	12.50	—	$7.00 SUPPLIES
6	1.60	12.05	$15.00 FERRY+TOLL
7	7.30 GR	11.00	$7.40 BOOKS
8	1.50		
9	2.00		
10	X	X	
11			
12			
13			
14			
15			
16			
17			
18			
19			
20			

The logbook expense ledger. (Left)

Heat-Moon cut it close. After eighty-two days, he arrived home with less than ten dollars in his pocket. He said, "People have accused me of lying about making the trip on only four gasoline credit cards and a little over six-hundred dollars. Here's my evidence." He left home with $428 under the dash and $26 dollars in his wallet. His uncle in La Grange, Kentucky, sent $20 with him on March 22. "He wanted to go with me, but instead he hid a twenty-dollar bill in the van and said, 'You find it.'" It was under the dashboard. Heat-Moon made $5 loading blue crabs in North Carolina on March 30. He received $10 in the mail three times during the trip, April 9, 21, and May 26; the first two from his father (RGT). The notation about "$100 cash" at the top of page 2, Heat-Moon cannot recall the meaning. And a rider contributed $4 for gas on May 24 for a total of $613. Non-gas total expenses—$604.95 (*BH* 8).

Washington Route 14 just east of Maryhill.

When I spotted this sign east of Maryhill, Washington, it was apparent that Heat-Moon was not the only driver to have to worry about an empty tank along that stretch. When he drove Washington 14, there was no such warning (*BH* 243).

Wallula Lake, Oregon, US 730.

Washington 14 runs along the northern bank of the Columbia River until it joins I-82. To stay on a blue highway, Heat-Moon turned south and crossed the Columbia River back into Oregon. He took US 730 (formerly part of US 12) east along the south side of the great bend of the Columbia that forms Lake Wallula. About thirty-six miles northeast, back in Washington, US 730 joins US 12 where he continued the journey eastward (*BH* 243).

The Palouse, east of Walla Walla, Washington, US 12.

This region of fertile hills and valleys is in southeast Washington and north-central Idaho. Heat-Moon describes it as "treeless, rounded hills, shaped by ice and wind and water to a sensuous nudity" (*BH* 244). This October photograph captured the post-harvest yellow wheat stubble and the brown of fallow soil.

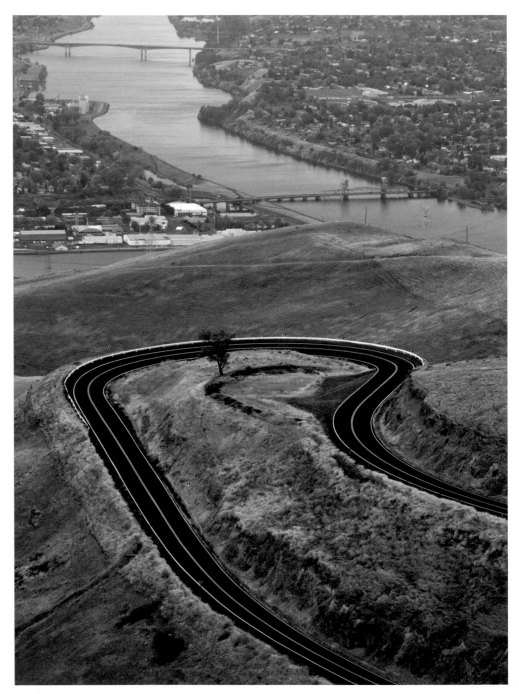

Old US 95 winding up Lewiston Hill, Idaho.

This view looking south from the top of Lewiston Hill shows one of the multiple 180-degree turns Old US 95 takes to ascend or descend the two-thousand-foot hill. Below is the Snake River between Clarkston, Washington, on the right and Lewiston, Idaho, on the left. Heat-Moon speculates that its "grinding steepness, is such a fearsome thing travelers often carry an extra pair of undershorts when forced to drive it" (*BH* 245).

North of Lewiston, Idaho, US 95.

Going north on US 95 through the Palouse, a phrase I read the night before in *Blue Highways* became fulfilled: "A few trees stood in the deep glens now going blue in the dusk" (*BH* 245).

Fred Tomlins in Moscow, Idaho, US 95
(photograph by Heat-Moon, 1978).

In September 2007 I passed through Moscow, Idaho, to look for Fred Tomlins and Moreno's, the Mexican cafe located in an old filling station. The owner of a local bookstore told me the restaurant had moved to Coeur d'Alene and was now named Eduardo's. I had been looking forward to an enchilada in the grease pit. I found Eduardo's the following day, but it took me a little longer to find Fred.

I found him in Eagle Point, Oregon, in 2009. He finished graduate school in 1979 with a master's degree in wild land recreation management, a year after meeting Heat-Moon. He accepted a job in Medford, Oregon, as an outdoor recreation planner and managed outfitters on the Rogue and Klamath Rivers. "We also had sixty miles of snowmobile trails and about twenty miles of cross-country ski trails and a tubing hill. I did the planning, the budgeting, and the schedules for the outfitters so they could take their clients down the rivers. I also did archaeology work—doing clearances before any disturbance, looking for prehistoric and historic things and endangered plants. I did that for twenty-seven years. With the seven years I had in the US Air Force, I retired in July 2006 with thirty-four years of federal service."

The people who cast the votes decide nothing. The people who count the votes decide everything.
— Josef Stalin

Fred Tomlins in Eagle Point, Oregon, May 2009.

"Now I play golf, hunt turkeys, do gardening. My daughter Haley and wife, Leah, just came home with twenty-two chickens, six ducks, a rabbit, and six fish. We already had five goats—but everything else is new and now they've got a new puppy. So I had to build a chicken coop, a duck pen, a rabbit hutch, and holy moly."

I asked Fred if he still flew, and he said, "I stopped flying once I got here. I'd fly for an hour but you were only thirty minutes from town—just boring. I was used to going a thousand miles in an hour and a half—flying up to 50,000 feet, but just smashing bugs in a Cessna—it just wasn't worth the price." I reminded Fred of Heat-Moon's description of their 1978 flight in the Cessna 150 over the Palouse and Snake River: "We pinwheeled above a silvery barn. Around and around, down, down. We were in a sharp descent." He wasn't sure Fred was going to pull out of the descent in time.

"Heat-Moon made that flight sound a lot more exciting than it was." I suspected the difference in opinion was one of perspective. Fred told Heat-Moon his idea of having fun, "Flying ten feet off the ground at Mach one" (*BH* 249–52).

North of Coeur d'Alene, Idaho, US 95.

Could this be the silvery barn roof Heat-Moon saw as Fred Tomlins pinwheeled his Cessna to earth? The night before Heat-Moon started his journey in Columbia, Missouri, he met Fred Tomlins, a decorated, retired air force test pilot who invited him to visit if he ever got to Moscow, Idaho. Tomlins took Heat-Moon for a flight in his Cessna—not an F-100—but he flew like it was a fighter (*BH* 250–52).

Kootenai River, Montana, US 2.

Near Potlatch, Idaho, Heat-Moon picked up a hitchhiking missionary, Arthur O. Bakke, who carried everything he owned in a satchel and a small aluminum suitcase. They shared a ride and philosophies up US 95, then east into Montana, and along the Kootenai River on US 2 (*BH* 253–62). Bakke died on January 31, 2008, before I could find him. He still had his long, white beard.

Forest east of Hungry Horse, Montana, US 2.

The route was filled with larch—the colors more saturated because of low, dense clouds (*BH* 263).

McDonald Creek, Waterton-Glacier International Park, Montana, off US 2.

This scene is only several miles off the *Blue Highways* path. It's the kind of stream, had Heat-Moon gone into Glacier, that he would have had an irresistible urge to jump into—frigid, clear glacier water (*BH* 263). A raindrop that falls at Triple Divide Peak, just west of here, can flow into either the Columbia, the Saskatchewan, or the Mississippi depending just where—within inches—it lands.

Teddy Roosevelt Monument, in Marias Pass, Montana, US 2.

The obelisk, built in 1931, originally was to have been a granite arch spanning the new highway. Instead, it became a sixty-foot replica of the Washington Monument. When Heat-Moon saw it in 1978, the marker was "in the middle of the pavement" (*BH* 263). In 1989 it was moved just south of the highway, but still on the Continental Divide.

Browning, Montana, US 2. (Right)

After having seen a historical sign claiming the Blackfeet "jealously preserved their tribal customs and traditions," Heat-Moon was surprised to find the Warbonnet Lodge Motel and a concrete tepee serving hamburgers (*BH* 264). The Warbonnet Lodge is still in business, and so is the tepee, but now it serves espresso.

The Rocky Mountains from the grasslands to the east, Montana, US 2.

Seen from the plains to the east, just off US 2, the Rockies appear to leap from the horizon. The abrupt change from plateau to mountain is remarkable (*BH* 263).

Oil City Saloon, Shelby, Montana, US 2.

In Shelby, Heat-Moon found a tavern with a cast of characters from the "new Wild West": the spurned lady; Lonnie, her pretend defender; Chuckie, the dead-drunk cheese curl; and the Mountain Bell Telephone boys (*BH* 266–68). The Oil City Saloon is still open, but it has moved to a building a block farther west.

Cottonwoods following Clear Creek, twelve miles east of Havre, Montana, US 2.

While on the Great Plains Heat-Moon wrote, "the cottonwood still keeps to the streams as if it knows the primogeniture of the grasses" (*BH* 269).

Burnham School, five miles east of Kremlin, Montana, just off US 2. (Right)

As I was driving east in October 2007, I spotted this building some distance from the highway. The Burnham School was established in 1912. Charles Innman, the current owner of the school, told me the original structure burned in the early 1930s. The above building was moved from north of the Milk River (*BH* 270) to this location where it served as the school until 1946 when it became a granary. At one point, a local artist purchased it with the intent of using it as a studio but never did.

Missouri River, south of Wolf Point, Montana, several miles south of US 2.

After a long day of being pounded in his van by a highway full of potholes, Heat-Moon approached Wolf Point, Montana, on a stormy evening. It was a time much like in the photograph above, but with abundant lightning thrown in. On the radio he came across a revivalist stating, "Thou knowest, O Lord, we shall pass this way but once." With the rain assaulting his van and lightning striking close, Heat-Moon added, "Amen."

The next morning he passed through Plentywood, Montana, a town surrounded by a treeless landscape, where he took up the seemingly endless North Dakota Route 5: "On, on, on. Straight and straight" (*BH* 271–73).

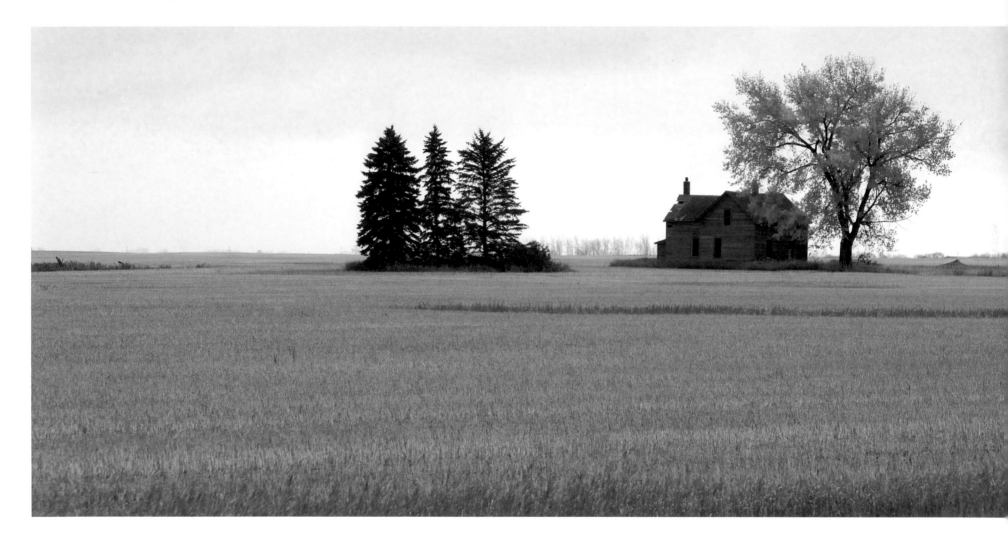

North Dakota Route 5.

Heat-Moon wrote, "The isolated immensity reveals what lies covered in places noisier, busier, more filled up" (*BH* 274).

"Fenceposts against the sky,"
North Dakota Route 5.

Just miles from the Canadian border Heat-Moon observed,
"things were angular: fenceposts against the sky, the line of
a jaw, the ways of mind, the lay of crops" (*BH* 273).

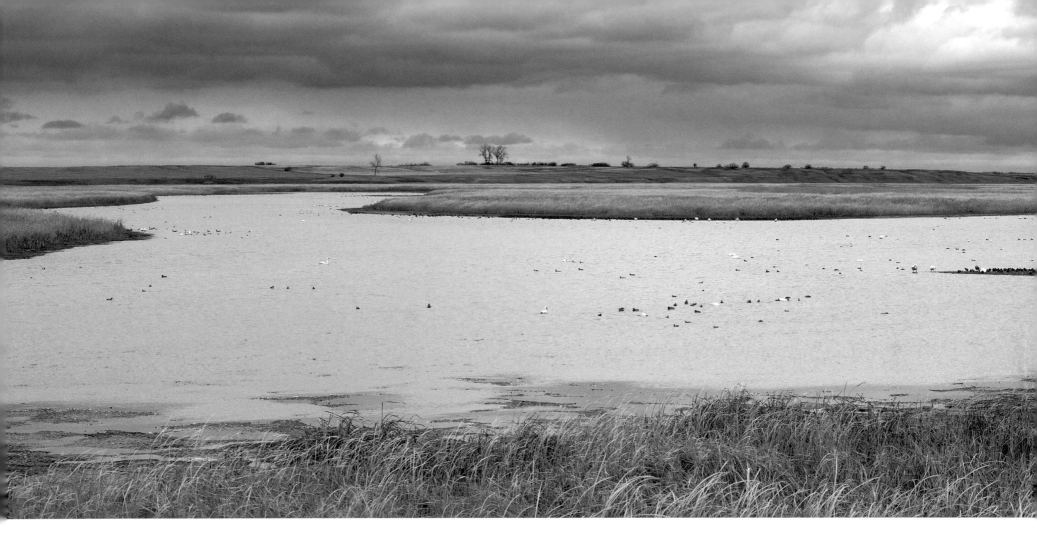

"Potholes ice sheets had gouged out," North Dakota Route 5.

When an occasional lake or pond created by glaciers got in the way of North Dakota 5, Heat-Moon noted, the road just passes right through it, "never yielding its straightness to nature." He conjectured that, "If you fired a rifle down the highway, a mile or so east you'd find the spent slug in the middle of the blacktop" (*BH* 273).

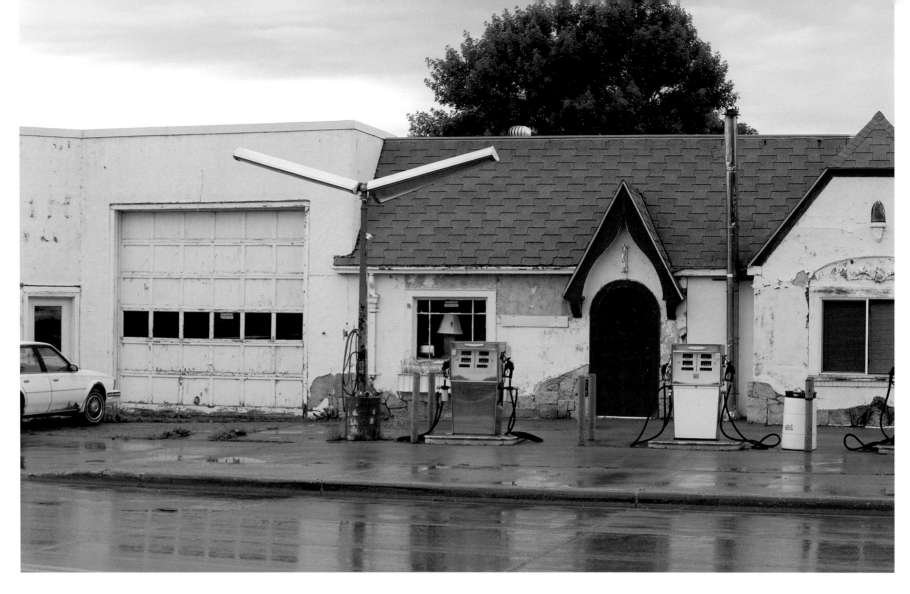

Service station, Cavalier, North Dakota, on Route 5.

As I approached Cavalier, I was looking for the garage where Heat-Moon got a fuel-line leak fixed. This now out-of-commission service station was it. To his surprise, the repair cost him only ten cents for the hose and two dollars for labor. But the young mechanic, "with the belly of a man," found a more serious problem in the water pump. "When those bearings give, fan's coming through your radiator and that'll be all she wrote." With no water pump available in Cavalier, Heat-Moon found a Chevrolet dealer in Grand Forks who replaced his water pump in an hour for $37.39 (*BH* 277–78). I called for an estimate to replace the water pump on my Ford F350: $450 to $500.

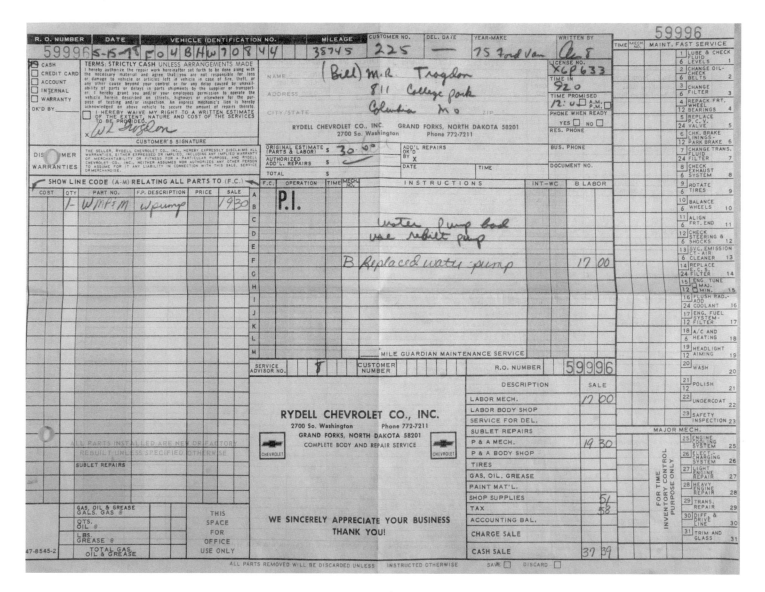

A new water pump for $37.39, Grand Forks, North Dakota, US 2.

Heat-Moon "had expected to be taken for three times that figure," but he "met only honest people" (*BH* 278). With Ghost Dancing repaired, he crossed the Red River into Minnesota.

D-R Cafe, Bagley, Minnesota, near the junction of US 2 and Minnesota Route 92.

Heat-Moon's first stop in Bagley was at the Viking House Cafe. In 1978, his GPS (gastronomic positioning system) was his nose. The Viking House is now the D-R Cafe.

"The people of the northern midlands—the Swedes and Norgies and Danes—apparently hadn't heard about the demise of the independent, small-town bakeries; most of their towns had at least one," Heat-Moon observed (*BH* 279–80). Bagley residents still haven't heard the news—the Bagley Bakery is still in business.

Main Street Tavern, Bagley, Minnesota, on Route 92.

The Michel's Bar that Heat-Moon visited in 1978 (*BH* 280-281) is gone—just an empty lot. But across the street, the Main Street Tavern has filled the void.

*Fishing up a storm on Lake Lomond, in the
City Park, Bagley, Minnesota, on Route 92.*

Bagley is still "a village with pines and a blue lake" (*BH* 279)—when the sun
shines. The day I was there, the sky had no blue to lend color to the water.

Heat-Moon's boots and sunglasses.

In the photograph of the author that appeared on the dust jacket of the first edition of *Blue Highways*, Heat-Moon wears these boots. In Red Wing, Minnesota, where the boots are made, a woman read the book and studied the jacket photo. She wrote Heat-Moon to tell him she liked the book, adding, "I see you're wearing our Red Wing boots. Here is a certificate for a new pair."

Also in the photo are his Ray-Ban sunglasses, which he wore through the trip. He bought them at the Navy Exchange in 1963 while stationed at Newport, Rhode Island.

Lake Itasca, headwaters of the Mississippi River, off Minnesota Route 200.

Heat-Moon describes the beginning of the 2,320-mile-long Mississippi River as "a twelve-inch deep rush of cold clarity over humps of boulders" (*BH* 282).

Mississippi River near Jacobson, Minnesota, on Route 200.

Heat-Moon notes that less than a hundred miles from Lake Itasca, the Mississippi "already flowed in olive murkiness" (*BH* 283). Just east of here, Minnesota 200 joins US 2, which he followed east to Duluth and across the St. Louis Bay Bridge into Wisconsin.

Lake McLain, Wisconsin, on Route 77.

After a night in Ghost Dancing being pestered by ticks and mosquitoes, Heat-Moon stopped at Lake McLain to jump in and "scrub everything out that wasn't me." Later, he was approached from the woods by a teenage girl trying to escape from an abusive father, "a pitiful mess of mosquito bites and stringy hair" who had spent the night in the woods without shelter. In his mind he heard a headline warning, "Parents File Charges against Unemployed Man," but his concern for the girl outweighed his concern for the risks, and he gave her a ride to her grandmother's home in Green Bay (*BH* 284–88).

Reflections in Chequamegon National Forest, Wisconsin, on Route 77.

Heat-Moon describes the Chequamegon Forest as "trees and sandy soil blooming with trillium" (*BH* 286). Most trillium species bloom from April to June, so my passage in mid-July turned up no trillium blossoms. I did find fields of white daisies beside this lake adjacent to Highway 77.

The vehicle deck of the SS Badger, the ferry from Manitowoc, Wisconsin, to Ludington, Michigan.

The *Viking* no longer runs between Kewaunee and Elberta; but in Manitowoc, Wisconsin, about twenty-five miles south of Kewaunee, I caught another ferry across Lake Michigan to Ludington, Michigan. Heat-Moon, distracted by a Bavarian-born storyteller, failed to resolve a question—"Whether all shore lines disappear on a clear day in the middle of Lake Michigan" (*BH* 290, 292). Two hours and five minutes into the four-hour trip, I can report no land was visible in any direction, and it was a clear day.

Heat-Moon's ticket on the Viking to cross from Kewaunee, Wisconsin, to Elberta, Michigan. (Left)

Heat-Moon on May 18, 1978, paid $27.50 for his crossing—a strain on his $600 budget. The charge for me and my van was $137.

Sunset, Frankfort, Michigan, on Route 115.

The ferry Heat-Moon rode landed near here (*BH* 292).

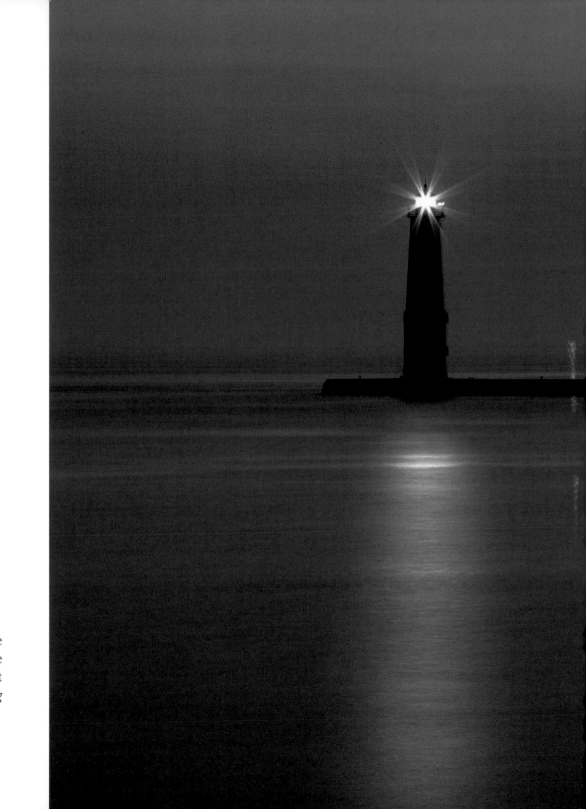

North Breakwater Light, Frankfort, Michigan, on Route 115.

This light was constructed in 1912 on one of the twin piers at the entrance of Lake Betsie. After completion of breakwaters in the early 1930s to create a larger protected harbor, the North Light was lifted and moved to this position—a landmark for the *Viking* that carried Ghost Dancing across Lake Michigan (*BH* 292).

Saginaw Bay on Lake Huron, Bay Port, Michigan, on Route 25.

Heat-Moon wrote, "On the map, lower Michigan looks like a mitten with the squatty peninsula between Saginaw Bay and Lake Huron forming the Thumb. A region distinctive enough to have a name was the only lure I needed" (*BH* 295). From Bay City he followed Michigan 25, which outlines the Thumb. This scene is halfway up the inside of the thick first digit.

Nugent Pharmacy, Caseville, Michigan, on Route 25.

Heat-Moon describes Michigan 25 along Saginaw Bay from Caseville to Port Austin as "an uninterrupted clutter of vacation homes, tourist cabins, motels, and little businesses selling plastic lawn-ornament flamingoes and used tires cut into planters" (*BH* 295). The tire planters may no longer be in vogue, but pink flamingoes are still available at Nugent's—look in the left windows just above and to the left of the red-lettered "good neighbor pharmacy" sign.

Trescott Street Pier, Harbor Beach, Michigan, on Route 25.

It was a fisherman on the pier who told Heat-Moon where he could get a good hamburger. The fisherman added, "Be sure to see the painting. That thing stirs up almost as much commotion as a fast run of perch" (*BH* 297).

The Harbor Light Bar, formerly the Crow's Nest, Harbor Beach, Michigan, on Route 25.

I visited the Harbor Light in mid-afternoon and found Nelson Arsenault, the owner, preparing for the evening crowd. I asked if he was familiar with the book *Blue Highways*, and he said, "I think I seen it a long time ago. Did you write it?" I explained my mission to retrace and photograph Heat-Moon's route. Thirty years ago his place was the Crow's Nest. Remembering what it was known for, Arsenault pointed to the back bar and said, "They had a picture of an Indian girl on that wall. That wasn't there when I sold it to them. They put it up. She had a real nice tan. We still have the hamburger, but we don't have the picture." Heat-Moon describes the painting as a "bronzed-bodied blonde in Indian-style headband and loincloth. That's all she wore unless you counted the expression on her face" (*BH* 297–99).

Ontario

Early morning, St. Clair River from Sarnia,
Ontario, US Interstate 94/Ontario Route 402.

The *Blue Highways* path leaves the United States and crosses the St. Clair River from Port Huron, Michigan, to Sarnia, Ontario, for a short passage (250 miles) through southern Ontario. Heat-Moon wrote, "The showers kept at it, the traffic ran heavy, I got lost in London, and again in Brantford; finally I was just driving, seeing nothing, waiting to get off the road" (*BH* 303). Continuing east, he would cross the Niagara River, just north of the falls, back into the United States.

The Horseshoe portion of Niagara Falls.

I passed through Ontario on an overcast day, but without rain. I stopped in Niagara to see whether the Canadian sun would emerge and turn the "eastern cliffs orange." I didn't experience Heat-Moon's "unbelievable timing" (*BH* 303), but I saw the falls—all twenty-six hundred feet of the Horseshoe brink.

The Frontier House, Lewiston, off New York Route 18F.

The Frontier House, built in 1824, has both an honored and a haunted history. William McKinley and Mark Twain slept here when it was a hotel. Heat-Moon was told as he passed through Lewiston that James Fenimore Cooper wrote his novel *The Spy* there (*BH* 303).

The Freemasons used the fourth floor as a meeting place, and the building is supposedly haunted by a bricklayer who fell to his death under suspicious circumstances during its construction, after openly opposing the Masons.

The stone retaining wall, near Cheshire, New York, on Route 21.

The wall Scott Chisholm and Heat-Moon labored over was still there—if a little jumbled—when I visited Cheshire thirty-one years later. Just as Heat-Moon noted: "The wall would be there until other men came, and, with effort, moved it. Maybe nothing else he or I had done or would do would last as long as that wall."

Near Cheshire, I also found relatives of Pete, Pauline, and Filomena Masucci, another family Heat-Moon got to know while he was in the area. "Pete had walked with crutches since he was a small boy," Heat-Moon says, but in spite of his disability Pete with his wife, Pauline, and his mother, Filomena, moved to the farm (*BH* 305–15).

Annette and Joe Frederick, Pauline's sister and brother-in-law, said Pete continued to work on the farm for several years after Heat-Moon's visit. Joe told me, "Pete didn't want to rely on anybody. He was independent. He had his tractor built where he could use his hands to work the brake and the clutch. And he drove. For the shape he was in, it was a miracle, you know. Today, you'd be in a nursing home. But back then they didn't have them places, and you had to make a living. But he done good. His wife was really behind him and helping him. Oh yea, he'd get on that tractor, and he'd be a happy man."

Annette phoned her sister Frances, who said Pauline died in 1981, Pete in 1986, and Filomena in November 1987. Filomena would have been 104 the following May.

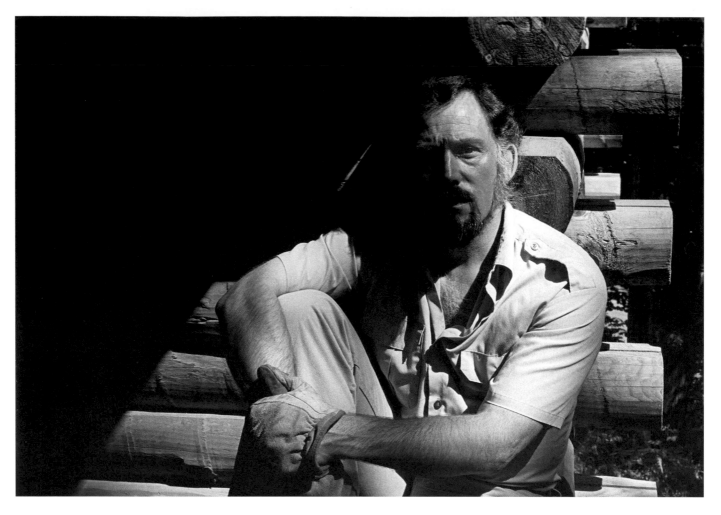

*Scott Chisholm near Cheshire, New York, on
Route 21* (photograph by Heat-Moon, 1978).

In Cheshire, New York, Heat-Moon visited Scott Chisholm, his wife, Linda, and their children, Sean and Caitlin. The men had been roommates as graduate students at the University of Missouri.

Even though Heat-Moon worked to physical exhaustion on Chisholm's retaining wall, "It appeared then as though I wouldn't have been able to travel another mile had it not been for these people. I suppose that wasn't true, but it seemed so" (*BH* 304–7).

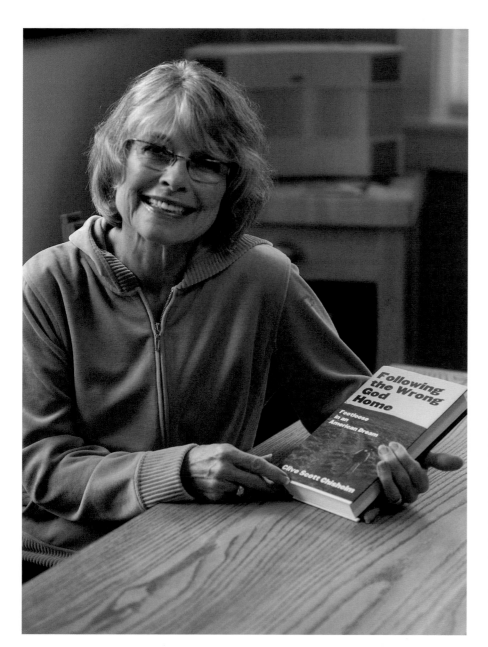

Linda Chisholm, October 2007.

Scott Chisholm died in 2007. Linda told me that Heat-Moon and *Blue Highways* were an inspiration to Scott and significant factors in his writing a book about hiking the Mormon Trail from Omaha to Salt Lake City. He planned the ninety-day trek to traverse each segment on the same day as on the first Mormon migration.

"It was pretty adventuresome," she said. "There were times when he was on tracks that people hadn't been on since the beginning. Once he was blown off the side of a hill in a snowstorm in his tent, and he woke up one day with rattlesnakes all around him."

His book is titled *Following the Wrong God Home.*

Main Street, Canandaigua, New York, on Route 21.

This is the central artery of town, which Heat-Moon described as lined with "brick buildings from another century" (*BH* 316). At its north end stands the Ontario County Courthouse where Susan B. Anthony was tried for voting in 1872. She was convicted and fined $100 plus court costs, but she never paid a dime of the judgment. I looked around the building to find a monument or plaque explaining the momentous event—that a woman would be so brave as to face being jailed to gain the right to vote for herself and, ultimately, all women in America. A lady in the county clerk's office knew of nothing there to commemorate Anthony's trial.

Ontario County Courthouse, Canandaigua, New York, on Route 21.

Where's the monument? (*BH* 317)

The Hill Cumorah Monument, New York, on Route 21.

Heat-Moon relates that the elevation "is not Mount Sinai or an Ararat, but rather a much humbler thing, yet apparently of sufficient majesty for angels and God to have chosen it as the place to speak to Joseph Smith" (*BH* 317). The gold statue at the top of the monument depicts Moroni, the angel who Joseph Smith said delivered to him in 1827 the golden plates from which *The Book of Mormon* was translated.

As I was setting up for this photograph, dark clouds rolled in fast. A lightning strike with earsplitting thunder told me to get off the hill before I was given my own personal introduction to an angel.

"Fields of . . . green, under . . . locust trees" still line New York 31 (BH 317).

This is another instance of coming upon a scene just as described in *Blue Highways*.

The Erie Canal at the edge of Lyons, New York, on Route 31.

The *Blue Highways* route followed Highway 31 east for the thirty miles between Palmyra and Savannah, roughly paralleling the Erie Canal (*BH* 317). Heat-Moon would pass through this lock some seventeen years later on his voyage that resulted in the book *River-Horse*.

The Cato Hotel, Cato, New York, on Route 370.

Heat-Moon "stopped for a sandwich at this old hotel, but the only food was pickled sausage at the bar" (*BH* 318). When I passed through in July 2008, Sharon Mulholland, the owner, had just closed the hotel for renovation. She finished it and reopened as the Olde Irish Inn, Pub and Restaurant on March 17, 2009. The date is no coincidence—St. Patrick's Day. As her new website says: "At the Olde Irish Inn every day is St. Paddy's Day, and every day you can enjoy corned beef and cabbage."

Cato Hotel Christmas greeting, 1939.

The hotel was built in 1810 and is the oldest building in town, though it does have a new phone number.

Goettel Community Park, Cato, New York, on Route 370.

Heat-Moon was directed here by the Cato police when they didn't like the spot he first chose to spend the night. He parked Ghost Dancing "equidistant between homeplate and the tombstones" (*BH* 319). Today there is a sign: PARK IS CLOSED DUSK TIL DAWN.

The former Ben and Bernies, New York, on Route 49.

The cafe, now Abbye Lynn's, "afforded a broad view of Lake Oneida" when
Heat-Moon passed through (*BH* 319). Trees now block the vista.

Lake Oneida, along New York Route 49.

In 1978 Heat-Moon reported that many of the homes on the north shore of the lake "were losing to the North climate, and for miles it was a place of sag and dilapidation" (*BH* 319). In 2008 I saw only handsome homes along the lake.

Fort Stanwix National Monument, Rome, New York, on Routes 49 and 46.

When Heat-Moon visited Rome in 1978, urban renewal in and around the fort made the city look like "London in 1946" (*BH* 320). Fort Stanwix once provided protection for the Oneida Carrying Place, the route for trade between the Atlantic Ocean and Lake Ontario. It now offers a beautiful green historical park in the heart of Rome.

The "Adirondacks Wall,"
New York, on Route 12.

Ghost Dancing labored to climb a "virtual wall" (*BH* 320).
The ridge was easy to identify both by the groan of my V-10
engine and by the sight of the green bluff below the skyline.

Forbidding forest, on New York Route 28.

The deeper Heat-Moon proceeded into the Adirondacks, the more the forest became "pervasive, ominous and forbidding" (*BH* 320).

I felt a similar sense of mystery following the curving roads through the thick woods. But without the rain, hail, and drizzly fog, the forest was less ominous. For me, the forbidding and ominous element was the thought of driving a twenty-one-foot van down Long Island into Brooklyn.

Adirondack chairs at Curry's Cottages, with a view of Blue Mountain Lake, on New York Route 28.

Heat-Moon describes the lake as "dominated by a bluish hump of the Adirondacks" (*BH* 321).

The former Forest House Lodge, now a private residence, on New York Route 28.

East of the village of Blue Mountain Lake, coasting down a hill on Highway 28, Heat-Moon to his delight discovered the Forest House Lodge (upper photograph), an antique roadhouse—"part house, part tavern"—with a neon sign glowing orange in the mist (*BH* 321–22). The Forest House Lodge had served travelers since 1881.

In 2008 I knocked on the door and was greeted by Annelies Marini and Temple Taylor. I explained my *Blue Highways* quest, and they invited me in. They told me the lodge closed around fifteen years ago. Annelies, in a German/French accent, explained that their home was not the same building that was erected in 1881, but they had a digital copy of the 1885 photograph Heat-Moon saw hanging on the wall (lower photograph). They directed me to Bill Zullo, curator of the Indian Lake Museum, where I learned that the original Forest House Lodge burned down in 1934 and was rebuilt to the shape that we see today.

Forest House Lodge, August 11, 1885
(photograph furnished by Temple and Annelies).

Fort Ticonderoga and Lake Champlain as seen from Mt. Defiance off New York Route 74.

As Heat-Moon waited "under the dark brow of the fort" for the Ticonderoga ferry and passage to Vermont, he reflected on the significance of the fort's strategic location where Lake Champlain narrows and where the La Chute River empties from Lake George into Champlain (*BH* 322). The narrowing is visible in the upper portion of this photograph, and the La Chute is the narrow passage below. The fort controlled the movement of goods between the lakes—the key north–south supply route.

*Lake Champlain from New York
Route 74, where the ferry crosses.*

Heat-Moon points out that, "after Ethan Allen and Bene-dict Arnold captured Fort Ticonderoga in 1775," which was the first major American victory of the Revolutionary War, "the crossing became a critical link in holding the north-western portion of the colonies" (*BH* 322–23).

The British reoccupied the fortress after they were able to place cannons on Mt. Defiance. The view from the moun-tain (previous page) graphically explains its strategic ad-vantage over Ticonderoga. The British then abandoned the fort, in 1777, after their surrender at Saratoga.

The fortification is renovated and replete with soldiers and women in revolutionary period dress.

Buxton's Store, Goshen Corners, Vermont, on Route 73.

Instead of "Salada Tea lettered in gold on the front windows," which Heat-Moon saw (*BH* 323), I found signs for Mountain Lottery Megabucks Sold Here, Slush Puppies, Pure Vermont Maple Syrup, Fishing and Hunting License, Big Game Reporting Station, and poster-size ads for DVDs. A downpour created vertical streaks in the photograph.

Beside Vermont 73 east of Goshen. *(Left)*

Blue Highway 73 traverses the Green Mountain National Forest where this stream flowed heavily after the storm. (*BH* 323)

Barn on Vermont Route 107.

Heat-Moon followed Routes 73, 100, 107, and 12 to Woodstock. "Before realizing it, I was nearly across the narrow state" (*BH* 323).

The Green at Woodstock, Vermont, on Routes 12 and 106.

As Heat-Moon drove into town in 1978, he had the feeling he was on the set of an Andy Hardy movie, or perhaps in a Norman Rockwell painting. He concluded that, if "the townspeople wanted to make the claim" that theirs was the "prettiest village in America," he wouldn't dispute them (*BH* 323).

Woodstock, Vermont.

The Green today is still surrounded by "Georgian and Federal houses, with white picket fences," as it has been for years (*BH* 323).

Formerly the Bagley Tourist Home, Woodstock, Vermont, US 4.

Heat-Moon spent a night here—one of the three nights he paid for lodging. He wrote, "If you keep a mental list of things in America that you can kiss goodbye, add the tourist home to it. As an institution it isn't extinct, but nearly so" (*BH* 325–26). In the 1980s, the Bagley Tourist Home was sold and became an insurance and real estate office. In 2008, the building was converted to a veterinary hospital, and in one of the renovations, the porch where the author sat to watch the mountains got closed in.

The Woodstock Inn, Woodstock, Vermont.

Heat-Moon described the Woodstock Inn as "a big posh place of high-polish maintenance" (*BH* 323–26). It's still big, posh, and polished.

Of the *Blue Highways* landmarks, Bentley's Restaurant in downtown Woodstock remains open, but the old fire station over Kedron Brook has been converted to a vintage clothing store.

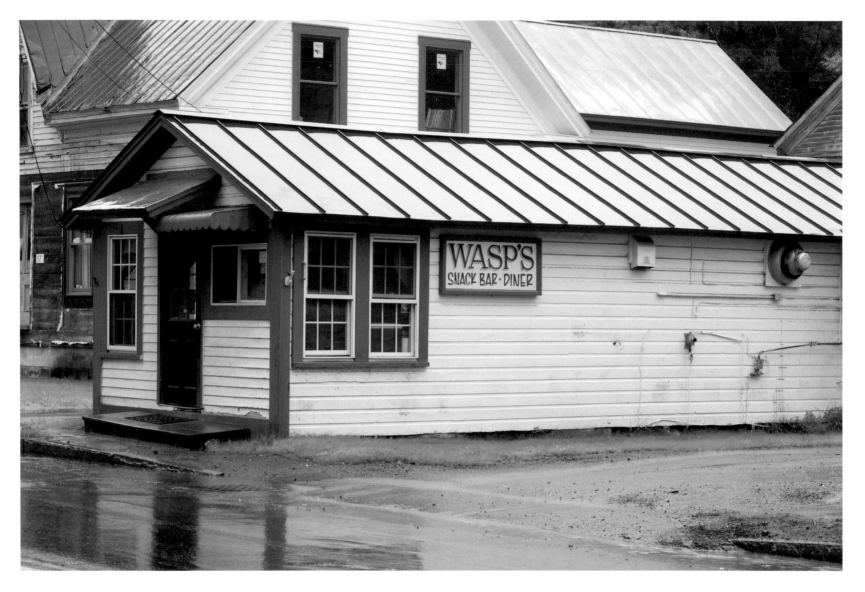

Wasp's Snack Bar-Diner, Woodstock, Vermont.

The eatery takes its name from the high school mascot. While eating at this three-calendar diner, Heat-Moon learned about a man who corrected his marital problems simply by changing his undershorts (*BH* 328).

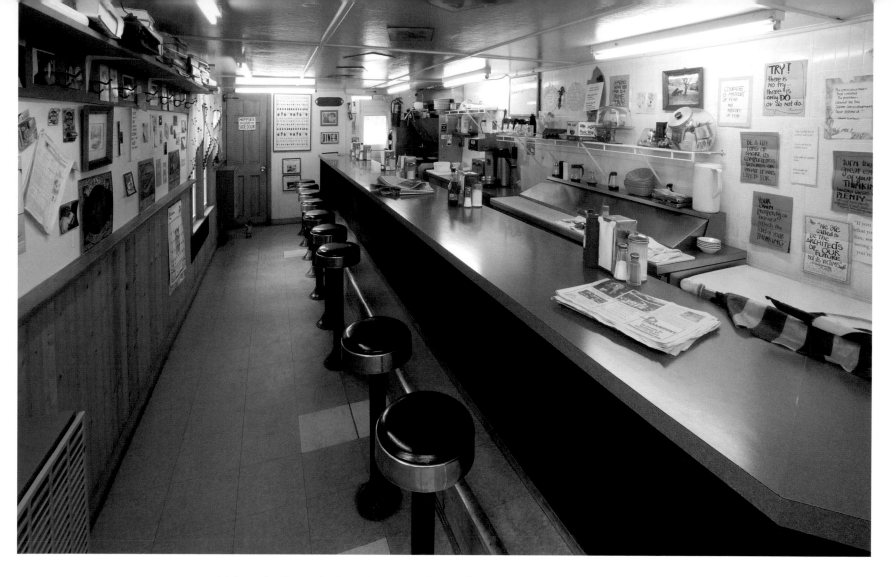

Wasp's Snack Bar-Diner, Woodstock, Vermont.

The Wasp is now owned by Jill Johnssen. It was operated by John Audsley when Heat-Moon ate there in 1978. Jill and her employee, Nicole Bartner, serve breakfast seven days a week—7 A.M. to 2 P.M. Monday through Friday and 8 A.M. to noon on Saturday and Sunday. My previous visits to Woodstock were in late afternoon. In May 2010, I once again arrived after closing; so I spent the night, to photograph the interior the next morning, and joined the early Sunday morning crowd for breakfast. It was worth the wait—biscuits and gravy, home fries and a side of polenta, but I saw only a single calendar. Jill should add a few. Heat-Moon sat at the stool nearest the camera.

Paul Revere Bells, Woodstock, Vermont.

Heat-Moon wrote that, in 1978, the town boasted four Paul Revere bells (*BH* 324). In 2008, two were easy to find: the oldest, made in 1818, sits outside the Congregational Church (far left); the second oldest, made in 1823, is in the courtyard behind the Woodstock Inn (left center). I asked numerous residents of Woodstock about the location of the other bells, but few people knew. With persistence, I found two other bells: one in the St. James Episcopal Church, made in 1827 (center), and the other in the Unitarian Church, made in 1835 (center right). In 2009 I read of a fifth Paul Revere bell in the Masonic Temple, formerly the Christian Church, made in 1827 (far right). I returned to Woodstock in May 2010 to photograph the fifth location and spend the night so I could eat breakfast at the Wasp.

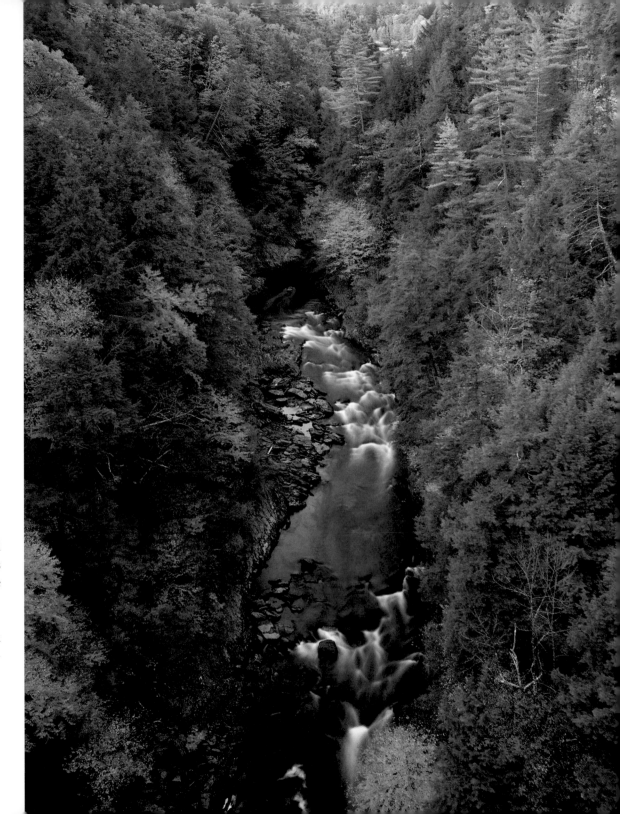

The Quechee Gorge, Vermont, US 4.

As the highway crosses the cleft, one sees "an unexpected hundred-sixty-five-foot-deep sluice cut through stony flanks of the mountain" (*BH* 328). This mile-long canyon cut by the Ottauquechee River is Vermont's Little Grand Canyon.

About six miles farther east on US 4 and five miles north on US 5, Heat-Moon crossed the Connecticut River into Hanover, New Hampshire.

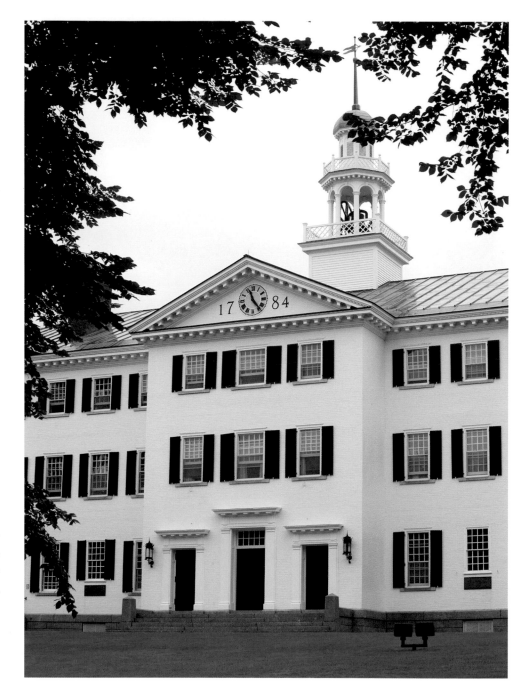

Dartmouth Hall, Dartmouth College, Hanover, New Hampshire, on Route 10A.

Although the school was founded in 1769 by the Reverend Eleazar Wheelock to educate Indian children, Heat-Moon noted that in 1978 only 1 percent of the student body was Indian (*BH* 328–29). Today, the enrollment of American Indians is about 3 percent, and the team mascot is no longer the Indian. *The Green* serves as the school symbol.

Pleasant Valley Store, West Canaan, New Hampshire, US 4.

Although no longer the Al's Steamed Dogs Heat-Moon saw, an EAT HERE AND GET GAS sign has remained (*BH* 329).

Melvin Village, New Hampshire, on Route 109.

Following the northeast border of Lake Winnipesaukee, Heat-Moon drove into Melvin Village, tucked between the Ossipee Mountains to the north and the large lake to the south. He found an "absolute calm [among the] white clapboard and black-shuttered houses," with the only sound coming from "the diminutive Melvin River—sliding over a dam of commensurate size" (*BH* 329). Again, he described perfectly a scene that lay before my eyes thirty years later.

Former home of Marion Horner Robie, Melvin Village, New Hampshire.

"Her white clapboard house, a long two-story building with a wooden sidewalk porch and boxes of red geraniums, thrust its north foundation [left in the photograph] into the Melvin River just downstream from the dam."

Marion, in her eighties when Heat-Moon visited her, explained to him how "our apartness has preserved us" (*BH* 331–32).

Pope Dam, the Melvin River, Melvin Village, New Hampshire.

The dam is located about seventy-five yards behind Mrs. Robie's former home (*BH* 331).

Tom Hunter near Melvin Village, New Hampshire, on Route 171 (photograph by Heat-Moon, 1978).

Mrs. Robie told Heat-Moon that if he really wanted to get the feel of the area he should meet her second cousin Tom Hunter. "He's a sugarmaker and one of the few old-line families still farming their original land. Up there's the feel. And maybe the end of an era." Tom explained to Heat-Moon, "Sugarin's a business to us if you look only at the ledger. But in all other ways, sappin' season's the time when the kids come home and my wife cooks for two hours to prepare a meal for eleven of us. We live the life of the old-day Hunters then. I can tell you, the sweet smell of syrup at boil and the cold wind outside and the pine burnin' in the box—it gets in your blood. I'll bet you could tap me and get five percent" (*BH* 334–38).

Jeff Hunter, Tom's oldest son, at the sugarhouse, near Melvin Village, New Hampshire, 2008.

Jeff, his eight siblings, and their families make up the sixth generation to sugar on their land. The seventh and eight generations now also contribute.

Three-gallon galvanized sap buckets in the Hunter sugarhouse.

Tom Hunter explained to Heat-Moon that a corn farmer "can't eat from the same stalk" as past generations. "But an old syrupin' family eats from the same tree." These buckets have helped harvest sap for multiple generations (*BH* 336).

Back of the Hunter sugarhouse door.

Heat-Moon observed that the doorjamb and back of the sliding door chronicled the syrup production since 1924. "As family albums are to some men, that doorjamb was to Tom Hunter" (*BH* 336).

The Hunter sugarhouse near Melvin Village, New Hampshire.

Built by Tom Hunter's father in 1922 (*BH* 336).

*Stone fence on the Hunter place,
near Melvin Village, New Hampshire.*

This is a section of "walls laid by the first three generations of Hunters,"
only twenty-eight miles from the Maine border (*BH* 336).

*Kennebunk River, Kennebunkport,
Maine, off Maine Route 9.*

As when Heat-Moon visited, they still unload fish and lobsters" on the river at Government Wharf (far right in the photograph) (*BH* 343–44).

*Path to Kennebunk Beach,
off Maine Route 9.*

Heat-Moon drove down to this beach—"blocked at both
ends by big broken mounds of glaciated rocks," partially
covered by drifting sands (*BH* 344).

Kennebunk Beach, off Maine Route 9.

Heat-Moon wrote, "People lay in the sand . . . children dug holes, mothers read fat novels by women with three names, and fathers read the coeds' damp T-shirts" (*BH* 344).

Kennebunkport, Maine, on Route 9.

Heat-Moon observes that most of the visitors stayed on the north side of the river in the shops and galleries, but a few found the southside eateries, small and slanty, the ones on pilings out over the river (*BH* 344). The Clam Shack, one of the most well-known stalls of its kind, is indeed over the Kennebunk River.

"School boys came down with their Zebcos to fish for pollock," off Maine Route 9.

On the Cape Porpoise town pier, I came upon a boy fishing—yes, with a Zebco in his hand!

It was here Heat-Moon met Tom West, skipper of the commercial trawler the *Allison E* (*BH* 345–46).

Tom West aboard the Allison E *near Cape Porpoise, Maine* (*photograph by Heat-Moon, 1978*).

In 2008 near Kennebunk, Maine, I talked with Tom West, skipper of the *Allison E*. Several years after Heat-Moon's visit, West sold his forty-foot and purchased a sixty-three-foot trawler, the *Bonnie Jean II*, named after his father-in-law's boat.

He said, "It was a big boat—drew ten feet of water. We were doing pretty good with a small boat, but it was kind of dangerous with the amount of fish we were catching. So we got a bigger boat—I never should have done it, really. Regulations changed on the fishing. And since then, they've changed a lot more. They changed the size of the mesh on the twine so you couldn't catch as many fish and then they limited it to 15 days a year to drag for ground fish. Then the [insurance] companies that were carrying us dropped our coverage. A bunch of boats down in Lawson sunk. They figured that because of the changes in regulations, people were scuttling their boats to get out of them. My boat, the *Bonnie Jean II*, sank about two years after I sold it. I don't know what happened. To get insurance on it went from $7,000, to buying it through Lloyds of London for $25,000."

Tom West, near Kennebunk, Maine, 2008.

When it became almost impossible to make a living fishing, West went back to school to earn a degree in education and become a middle-school principal. He had to retire prematurely in 2001 after developing grand mal seizures. "I ended up on the floor one day," he said. "I had convulsions and was stiff as a kid with the earaches. The doctor said I was either going to retire or I wouldn't be around in a couple years. You know it's hard to do, because I'd only been in administration for six to seven years, and you work so hard to get there."

A new medication has allowed him to resume activity, including spending six months of each year in Florida with his family. If he still yearns for his days fishing, I couldn't detect it. "It was hard work—there is no eight-hour day to it. You know, when you're not fishing you're working on your gear" (*BH* 345–57).

Drawings Heat-Moon made while aboard the Allison E.

In writing later about his day at sea with Tom West, Heat-Moon used the sketches to check the accuracy of his descriptions (*BH* 347–57).

Cape Neddick Light, Maine, US 1A.

After his day on the *Allison E*, Heat-Moon headed south on US 1 (*BH* 357). Cape Neddick Light is just fifteen miles south of Kennebunkport. Twenty miles farther on, he was out of Maine, and then another twenty miles and he was through New Hampshire and into Massachusetts, where he took I-95 around Boston to exit at Newton to get back on a blue highway, Massachusetts 16.

Cemetery in Holliston, Massachusetts, on Route 16.

Heat-Moon stopped here for lunch and a bottle of Moxie. It was the most popular soft drink in America until the 1920s. He points out that the beverage, originally a patent medicine in 1876, once claimed to be "the only harmless nerve food known that can recover loss of manhood, imbecility, and helplessness" (*BH* 358).

**Lieutenant Joseph Mellen's grave,
Holliston, Massachusetts, on Route 16.**

Heat-Moon ate lunch while he walked among the markers.
"Near the south end of the cemetery, under a big ash, was
Lieutenant Mellen's stone." He quotes the verse inscribed on
the lower third of the 1787 headstone:

*Behold and see as you pass by,
As you are now so once was I;
As I am now so you must be,
Prepare for Death & follow me.* (BH 358)

Bannister's Wharf, Newport, Rhode Island, on Route 138.

Heat-Moon wrote that this wharf was named after "Pero Bannister, a long-nosed oysterman, [who] died suddenly and had to be buried in a makeshift coffin so shallow the undertaker was forced to cut a hole in the lid for Pero's nose" (*BH* 360). Beyond this entryway is a large array of expensive motor and sailing yachts.

Bannister's Wharf, Newport, Rhode Island.

No longer do fishermen pitch pennies, bet on impromptu dog fights, or sell fish from wheelbarrows (*BH* 360).

The Claiborne Pell or Newport Bridge, Rhode Island, on Route 138.

The bridge spans the East Passage of the Narragansett Bay between Newport and Jamestown. As Heat-Moon crossed the bridge, he said to the toll keeper: "Damn expensive bridge—the toll, that is." The attendant replied, "We got a joke here. It's high because it's high." The 11,247-foot-long bridge has a clearance of 206 feet—enough to allow aircraft carriers once stationed at Quonset Point Naval Air Station to sail under it. The bridge was opened in June 1969, and "as soon as the paint dried, the Navy pulled its birdfarms out of Narragansett Bay," including the one Heat-Moon was stationed on in the early 1960s (*BH* 362).

The Towers, Narragansett Pier, Rhode Island, US 1A.

The Towers, built in 1883–1886, still bridge Ocean Road next to the beach. The Victorian-era hotel where Heat-Moon ate, the Green Inn, burned in 1980 and was replaced by two green-roofed, shingle-sided condos, but you can't replace a grand old hotel (BH 364). One other thing has changed since Heat-Moon's tour in the Navy at Quonset Point and his return in 1978: most of the tattoos visible on Narragansett Beach are not on sailors' forearms, but just above and below the bikini line on young women's backsides.

The Pawcatuck River between Westerly, Rhode Island (right), and Pawcatuck, Connecticut (left), US 1.

From Narragansett Pier, Heat-Moon continued almost due west along the coast of Rhode Island. As he crossed the Pawcatuck River into Connecticut, he realized he was heading straight for New York City. He could either "drive far inland to bypass it or take the New London–Orient Point ferry to Long Island and cut through the bottom edge of the Apple." He chose the latter (*BH* 365).

The oyster sloop Nellie (left), Mystic Seaport, Mystic, Connecticut, US 1.

About eight miles after crossing the Connecticut border, the *Blue Highways* path passes through Mystic and the Mystic Seaport. *Nellie* was built in 1891 to dredge for oysters along the shores of Connecticut and Long Island Sound—water that Heat-Moon was about to cross (*BH* 366).

The New London Harbor Light.

As the ferry left New London harbor, Heat-Moon, looking west, described "grassy homes and an old lighthouse" (*BH* 366). The original New London lighthouse was the fourth built in North America and the first lighthouse on Long Island Sound. Its construction was funded by selling lottery tickets in 1761. The first lighthouse was replaced in 1801 with the 89-foot octagonal stone structure still standing.

Downtown New London, Connecticut, US 1.

Heat-Moon found one similarity between London, England, and New London: "the old-world street system—nowhere a true square or rectangular block Even Benedict Arnold's 1781 torching of the town didn't help straighten the lanes" (*BH* 366).

The MV John H, the New London to Orient Point ferry, Orient Point, New York, on Route 25.

Heat-Moon's ferry was a World War II LSM— "an old oily tub." The *John H*, built in 1989, is more modern. I paid the $51.20 fare for my sixty-two-minute passage to Long Island, and an attendant drove my van aboard. Heat-Moon wrote, "We crossed the east end of the sound over a strip of water known as 'The Race' and passed close by a small, brushy island topped with a smokestack" (*BH* 366–68). The ferry still passes within a mile of Plum Island, site for research on deadly bacteria and viruses, where a security vehicle stood ready to warn off curiosity seekers. Above is the Orient Point landing at the northeast end of Long Island, about one hundred miles from Brooklyn.

Corey Creek Winery, Southold, Long Island, New York, on Route 25.

Since Heat-Moon's visit to Long Island in 1978 (*BH* 369), a good portion of the land once occupied by vegetable truck farms has been converted to vineyards, a topic he wrote about some years later.

Coney Island, New York City, near the Shore or Belt Parkway.

The foreboding I felt in the Adirondacks at the thought of driving a large van through Brooklyn was worry wasted. I had no trouble in traffic or problem finding a place to park for this photograph.

The Wading River just south of Jenkins, New Jersey, on Route 563.

"Tannins had turned the transparent water the color of cherry cola." This dark water, called "cedar water," Heat-Moon relates, was preferred by sea captains of yore on their prolonged voyages "because it remained sweet longer" (*BH* 372).

"Ye Greate Street," Greenwich, New Jersey, County Road 623.

As Heat-Moon describes Greate Street: it starts at "a rotting boat dock on the Cohansey River," runs "northwest for two miles," and ends in the smaller village of Othello (*BH* 373). The Sunoco station once located in a 1760 house is gone—returned to a home. Arnold's grocery is now Tom and Mabel's Greenwich Country Store. Fortunately, little else appears to have changed. The homes that line Greate Street, most of them built before 1880, have been well preserved.

Along "Ye Greate Street."

Heat-Moon describes Flemish-bond brick structures under big sycamores with a few ornamented, wooden Victorian homes for variety. "Hidden in the tall marsh grass of the coastal low-land, the whilom seaport . . . was remarkable" (*BH* 373–74).

*A rotting boat landing on the Cohansey River
at the southeast end of Greate Street.*

Greenwich was a thriving port in 1701; but for a few twists and turns in history, it could have become a major center of commerce on the Delaware River. In the quiet village, "undisturbed for most of three centuries," Heat-Moon found "a story of the past, the future, the present" (*BH* 373, 380).

The Ewing House, Greenwich, New Jersey.

In 1834, James Josiah Ewing deliberately built his home at the foot of Maple Street to block it from crossing Greate Street, thereby preserving the integrity of the central thoroughfare (*BH* 379).

Previously The Griffin, Othello, New Jersey, County Roads 623 and 650.

At the northwest end of Greate Street stands The Griffin, built in about 1730. In 1978 it was the antique shop where Heat-Moon met Sally Watson and Barbara Rizzo and began his search to learn how Othello, the "Head of Greenwich," got its name (*BH* 374–79). It's now the home of Warren Adams.

Hope Creek Nuclear Generating Station (left) and the two-unit Salem Nuclear Power Plant (right).

These nuclear generators, three of the four in New Jersey, are ten miles from the 326-year-old village of Greenwich. As Roberts Roemer says in *Blue Highways*: "The problem of what we're doing lies in deciding what's the benefit of history and what's the burden. We're not trying to hold back the future, but we do believe what *has happened* in Greenwich is at least as important as what *could happen* here. The future should grow from the past, not obliterate it" (*BH* 382). Two of the nukes have been built since Heat-Moon's visit. Because of the efforts of Roberts Roemer, who died on September 22, 1997, and the work of the Greenwich Emergency Committee, when they did "*happen*" it was *not* in Greenwich.

The Leipsic lighthouse on Delaware Route 9.

Heat-Moon found this "old steel lighthouse implausibly at the edge of a cornfield" without any visible body of water. (*BH* 383).

The village green, Dover, Delaware, on Route 8 and US Alt 113.

Heat-Moon relates the story of Chief Justice Sam Chew who died in 1744. His ghost repeatedly showed up on the green at night, to the point where it was affecting the local tavern business. So in 1745 the townspeople dug a grave in the village green and in an elaborate ceremony with church bells ringing they buried the judge's ghost. It worked; he's not been seen since (*BH* 384). In 2008 I found no one who knew the location of the burial site on the green.

World War II observation towers south of Rehoboth Beach, Delaware, on Route 1.

They are "monuments to man's worst war, one that never reached this beach" (*BH* 384).

Atlantic sunrise, Delaware Route 1. (*Right*)

Near the concrete observation towers, Heat-Moon ate breakfast while walking along this shore (*BH* 384).

Ocean City, Maryland, on Route 528.

The shore here is no longer a "six-lane strip of motels and condominiums tied together by powerlines" (*BH* 385)—today it's eight lanes. From the Atlantic coast of Maryland, Heat-Moon traveled southwest about sixty miles on multiple blue highways to Crisfield at the edge of the Chesapeake Bay.

"The Great Pyramid of Crisfield," off Maryland Route 413.

This is a six-foot-three-inch time capsule, filled in 1976 with artifacts to commemorate America's bicentennial: photos, phonograph records, and a "forty-seven Mercury outboard motor" (*BH* 387).

The Captain Jason, Crisfield Dock, on Maryland Route 413.

The highway goes right down Crisfield's wide main street and dead-ends at the dock. The cafe where Heat-Moon ate, the Captain's Galley, no longer exists, but a restaurant by the same name does. It's located in a modern seven-story building next to the dock.

I was surprised, thirty years later, to find the *Captain Jason*, the very boat Heat-Moon took to Smith Island (*BH* 387). It is still making the eleven-mile run across Tangier Sound between Crisfield and Ewell, the main village on Smith Island, a four-by-six-mile islet only four feet above sea level.

Goat Island, Maryland.

On the approach to Smith Island the *Captain Jason* passes this old hunting lodge. It is now a shelter and sundeck for web-footed hunters.

Alice Middleton's former home, at Ewell, on Smith Island, Maryland.

When Heat-Moon visited this "three-story red-shingled house overlooking an intricate network of coves and guts in a marsh that stretched so far I couldn't see the bay," it was the home of Alice Middleton, "one of those octogenarians who make age look like something you don't want to miss" (*BH* 388). The house is now a cafe, The New York Experience.

Ruke's Seafood Deck, Ewell.

Heat-Moon ate dinner here, "an old shingled place with a broken cash-register drawer standing full and open. Beach flotsam hung about the room: embossed bottles turned iridescent with age, antique running lights, a worn dip net, broken crockery, an eroded block and tackle" (*BH* 393). Today Ruke's is still selling sundries and serving catch from the Chesapeake.

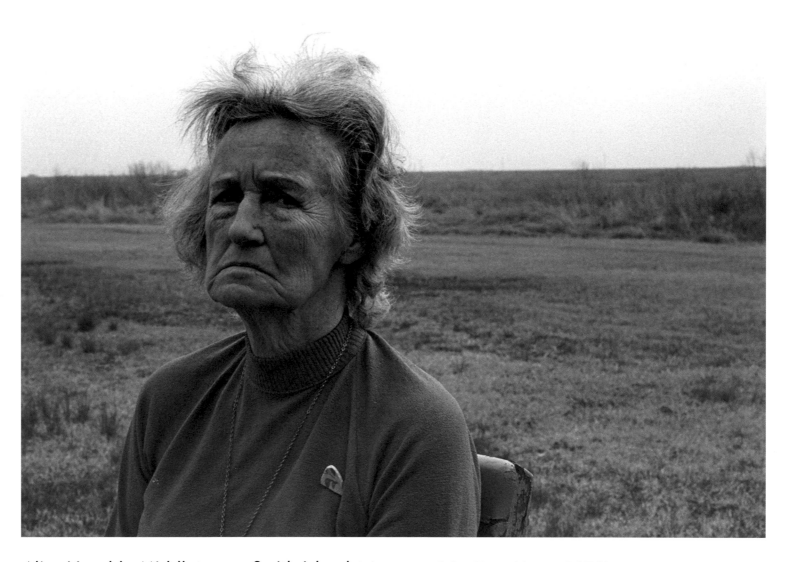

Alice Venable Middleton on Smith Island (photograph by Heat-Moon, 1978).

Alice told him: "A teacher should carry a theme—a refrain to sing ideas from. Mine was what they call 'ecology' now. I taught children first the system of things. Later we went to grammar and sums. Always time for that. I wanted to show them there's only one place they can get an education—in the school of thought" (*BH* 388–97).

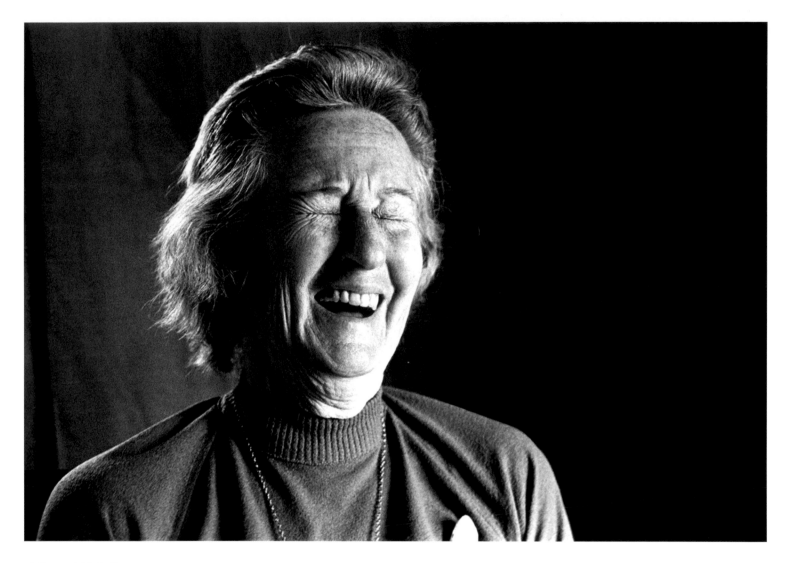

Alice Middleton (photograph by Heat-Moon, 1978).

The first photograph appeared in *Blue Highways*. Heat-Moon told me, "Alice had a fine sense of humor, but in the book I wanted to convey her indomitability although she would have preferred this jovial picture." Alice died on July 15, 1992, at age 95.

A gut (narrow passage) in the Smith Island salt marshes on the road between Ewell and Rhode's Point.

As Alice and Heat-Moon "tramped the dusty road over the guts, through the tall waterbush" to Rhode's Point, he asked what was "the hardest thing about living on a small, marshy island in the Chesapeake Bay."

"Having the gumption to live different," she replied, "and the sense to let everybody else live different. That's the hardest thing, hands down."

Alice had the opportunity to pass that philosophy on to many islanders. In her words, she taught school on the island "more years than the bottom's got oysters" (*BH* 394–97).

Salt marsh, Smith Island.

Seeing this boat reminded me of the story Alice told Heat-Moon of the *Island Belle*—a boat, residents told me, that now rests on the bottom of Ewell Harbor. It was the first gas-powered boat to make the passage from the Eastern Shore to Smith Island, and it changed the place. Alice said, "Before the *Belle*, people got to the Eastern Shore once a year—at Christmas. She brought passage. Regular comings and goings. We got outside and the outside got in. She ended our isolation. Carried mail and ideas, I deem. There aren't many places in the country that can point to one thing and say; 'Right there, *that's* the thing which changed us. *That's* what made us the way we are now'" (*BH* 396–97).

A telescope house.

After returning to the mainland, Heat-Moon headed northward, up the east side of Chesapeake Bay. He mentions telescope houses along Routes 413, 333, and 33. This style of dwelling over the years had two additions built on, each successively larger, so that the house appears as though—like a spy glass—the two smaller sections could slide into the largest addition (*BH* 397–98). I found this one eight miles off the *Blue Highways* route, near Beantown. It was once the home of Dr. Samuel Mudd, the physician who was tried, convicted, and later pardoned for treating John Wilkes Booth for the ankle he broke when he jumped to the Ford's Theatre stage after shooting President Lincoln in 1865.

The handwritten logbook page reads:

The telescope houses with their
standing seam tin roofs on peninsula.

OXFORD PICKETS

She met the town painting
her front fence one (first)
summer.

Coleman mentioned people making nativity
scenes in crab shells, and other tacky
crafty things from them.

The impressive fleet of skipjacks at
anchor at Tilghman. Last of sail powered
fishing fleet. So aboard to try out tonga—
look into cabins. A pure, commercial
fishing town.

A page from Heat-Moon's Blue Highways logbook.

The first drawing is a telescope house.

The second drawing shows an Oxford picket with the notation "She met the town painting her fence one (first) summer." Painting each picket, including the hole, gave her time to meet everyone passing down the street.

At the bottom of the page is a note about the skipjacks at Tilghman. All of these three items appear in the book, but the comment about "nativity scenes in crab shells, and other tacky crafty things" didn't make it (*BH* 397–99).

Oxford picket fence, Robert Morris Street, Oxford, Maryland, on Route 333.

Note the "hole shot" in the ace of clubs at the top of each board (*BH* 398). It isn't known who built the first Oxford picket fence, but photographs from the mid-1800s confirm they existed then. The town had its first annual tour of the fences with a silent auction of art painted on the planks in October 2009. At the end of Morris Street, Heat-Moon passed the Robert Morris Inn and caught the ferry across the Tred Avon River to Bellevue—riding on the oldest operating cable-free ferry in the United States.

A skipjack docked in the Knapps Narrows on Tilghman Island, Maryland, on Route 33.

Across the Tred Avon, Heat-Moon "drove out the double-fingered peninsula toward Tilghman Island." On the other side of the Knapps Narrows Bridge, he could "make out the tall masts and long bowsprits of the skipjacks, ships that hoist twelve hundred feet of sail to pull port and starboard dredges over the oyster rocks. Some people believed the skipjacks were the last of an era while others held they were, once again, the future." He pointed out, in 1978, that the skipjack is to the Eastern Shore what the bean pot is to Boston (*BH* 399, 403). Perhaps the comment encouraged Marylanders in 1985 to make the skipjack the state boat. When I visited Tilghman, I found only a single skipjack docked near the Knapps Narrows Bridge.

The Knapps Narrows Bridge, Tilghman Island, Maryland, on Route 33.

Tilghman is an island "only by virtue of a streamlet called the Knapps Narrows," Heat-Moon wrote (*BH* 399). This bridge crosses that small gap and provides the single land access between the island and the mainland. In 1998, the bridge that Heat-Moon crossed (built in 1934) was moved ten miles northeast to St. Michaels for display at the entrance of the Chesapeake Bay Maritime Museum.

Downtown Annapolis, Maryland, on Route 2, US 50, and US 301.

Heat-Moon ate fresh clams at Hannon's and drank Black Horse Ale. In 2008 I couldn't find either one. From Annapolis, the *Blue Highways* route followed Maryland back roads to curve southwest around Washington, DC, and crossed the Potomac into Virginia. There he took Virginia 218, "an old route now almost forgotten. The towns, typically, were a general store and a few dispersed houses around a crossroads: Osso, Goby, Passapatanzy" (*BH* 403)—names today found only in a Virginia gazetteer.

St. George's Episcopal Church, Fredericksburg, Virginia, on Routes 218 and 208.

Heat-Moon points out that Colonel Fielding Lewis, George Washington's brother-in-law, is buried under the church steps (*BH* 403). A pillar of his community at the time, today he provides a good foundation for future generations—or at least a step in the right direction.

From Fredericksburg the route traversed history-rich northern Virginia, over the Blue Ridge of the Appalachian Mountains and on into West Virginia.

*Ohio memorial for the Battle of the Bloody Angle,
near Spotsylvania, off Virginia Route 208.*

The battle got its name from the Confederate trenches, which formed an inverted U—the top of the inverted U became the Bloody Angle. "On that single day of May 12, nearly thirteen thousand men died fighting over one square mile of ground abandoned by both sides several days later. . . . Across the grassy meadow stood a shaft commemorating the Ohio contingent; among the carved names: Gashem Arnold, Elam Dye, Lewis Wolf, Enos Swinehart. . . . the warmth of the evening sun almost turned Bloody Angle to an idyllic meadow" (*BH* 405).

The Blue Ridge Mountains, Virginia, US 33.

Driving west on US 33, just west of Gordonsville, Virginia, once again a Heat-Moon description came into view—a "rumple of hills became a long, bluish wall across the western sky."

He knew that just beyond the Blue Ridge Mountains lay West Virginia and his journey was nearing its end—fortunately, since he had only sixteen dollars in his pocket. He asks at that point, "In a season on the blue roads, what had I accomplished?" (*BH* 406).

Michael Parfit answered that question in a *Los Angeles Times* book review: "William Least Heat-Moon has gone on quest, on the thin blue highways of America that drift like smoke. . . . He has come back and turned the quest around, and made a gift to us. . . . Heat-Moon walks through this book about our land and our people with a patient, eloquent, beautiful pace, his eye taking in everything and its meaning. Then he puts our words and our vistas into language that lives on the page."

Franklin, West Virginia, US 33.

Heat-Moon's description of Franklin—"a main-street hamlet sharing a valley with a small river as the Appalachian towns do"—is still apt today (*BH* 406). The stream is the South Branch of the Potomac River; from here a canoeist can float about 385 miles to the Chesapeake Bay.

US 33 through Germany Valley in the Allegheny Mountains of eastern West Virginia.

"The road, a thing to wrench an eel's spine, went at the mountains in all the ways: up, down, around, over, through, under, between. I've heard—who knows the truth?—that if you rolled West Virginia out like a flapjack, it would be as large as Texas" (*BH* 407).

The North Fork of the South Branch of the Potomac River at the base of Seneca Rocks, West Virginia, US 33.

It felt wonderful wading in this clear branch of the Potomac on an August afternoon. If something rocky sticks up, somebody has to climb it; and there were several groups scaling the sheer faces of the Seneca Rocks. The view from below was spectacular—I could only imagine the exhilaration to be felt up there. I wasn't finding the West Virginia that Heat-Moon experienced in 1978—I was seeing gorgeous streams, mountains, and valleys.

If you know any of Heat-Moon's books—*Blue Highways*, *PrairyErth*, *River-Horse*, or *Roads to Quoz*—you know he writes as he sees it. He mixes observation of minutia most of us would never notice with the ability to distill it all with stiletto-sharp insight that produces powerful and revealing descriptions. Anything in the crosshairs of that intellect may come across looking like an unflattering mug shot. So was the case with some of the West Virginia he saw in late spring of 1978.

I went looking for things he saw: old tires hanging from fence posts, dangling from trees, heaped in yards, sliding down hills. "It seemed as if West Virginia sat at the bottom of a mountain where America came annually to throw away their two hundred million used tires," he wrote. "Should you ever go looking for some six hundred million tons of ferrous scrap rusting away in America, start with West Virginia." He was especially frank about Sutton, in the heart of West Virginia (*BH* 407–8). It's not surprising that the secretary of state of West Virginia wrote him in 1983 to tell him never to return to the Mountaineer State. Heat-Moon, nevertheless, has been back multiple times and has noted some changes for the better.

My passage through West Virginia in 2008 couldn't have been more different—no roadside fields or yards with old tires, no abandoned cars or piles of rusty scrap. In Sutton I happened upon the owner and editor of the town paper, the *Braxton Democrat Central*, Craig Smith. I was setting up my tripod and camera to photograph what I concluded had been Elliott's Fountain in 1978. When I explained to Mr. Smith I was retracing and photographing the path of *Blue Highways*, he gave me a wry smile and explained that *that book* was never thought of fondly in his community or for that matter in West Virginia. He remained cordial but aggressively made the case that the depiction of the town didn't represent Sutton accurately. He went on to explain that the scrap iron and the mounds of old tires, although exaggerated, may have had a significant contributing factor. He told me West Virginia had to pay some of Virginia's debt after becoming a sovereign state in 1863—a payment not completed until 1939. He felt that this contributed to West Virginia having significantly less money to invest in infrastructure and services, including beautification of highways and right-of-ways. He suggested I look up the details, and I did.

The Civil War precipitated West Virginia's statehood. Only five days after Fort Sumter was attacked by the Confederacy, the Virginia General Assembly voted to secede from the Union. Within a month, delegates of northwest Virginia met to discuss the formation of the new state of West Virginia—to join the Union. The newly formed legislature applied for admission in December 1862, and West Virginia became a state in June 1863.

After the Civil War, there was the issue of Virginia's debt—what part of it belonged to West Virginia? In 1915, fifty-two years after it became a state, the US Supreme Court declared that West Virginia owed Virginia something more than twelve million dollars, a debt the state paid down over the next twenty-four years. At some point, state funding finally caught up with the pride of West Virginians, resulting in the cleanup of streams and scenery along highways across the state.

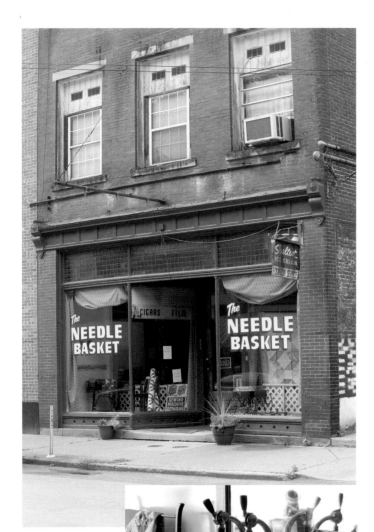

Formerly Elliot's Fountain, now the Needle Basket, Sutton, West Virginia, on Route 4.

A close look will reveal several details Heat-Moon mentions in his visit to the old soda-fountain: signs for Sealtest Ice Cream, cigars, film, and Coca Cola; floor tiles in the diamond-back rattler pattern (*BH* 407–8). But the Ex-Lax thermometer was gone.

Soda fountain.

"I drank a Hamilton-Beach chocolate milkshake, the kind served alongside the stainless steel mixing cup." Heat-Moon is of the school that believes the beaters hitting the metal cup "puts some of the flavor in" (*BH* 198, 408).

Floor tiles in the diamond-back rattler pattern.

Many feet have stepped on these tiles since they were laid over a hundred years ago. Heat-Moon was shown photographs of the soda fountain pharmacy from 1910 (*BH* 408).

The sign will read, "Welcome to Historic Sutton, the Heart of West Virginia."

As I drove west, I found a city council member and artist, Kathy Walker, painting a welcome sign at the edge of town. It was symbolic of the change visible to me as I followed the *Blue Highways* path across West Virginia. Heat-Moon has subsequently told me, "The citizens of West Virginia have done a good job of cleaning up the tires and trash. They were led in part by Secretary of State James Manion himself, who, I was told by a West Virginian, ran for office with a film-clip of his picking trash out of streams. So this man knew when he wrote me that the state

was clobbered with junk. He apparently made a contribution to reverse the degradation." Did Heat-Moon's criticism help as he hoped it would?

He recently told me, "Unfortunately some of the change is not for the better and wasn't obvious along the book's route you followed. The greater concern today is the environmental degradation of sections of West Virginia by the mining industry—the removal of entire mountaintops for coal that destroys forests and contaminates streams is more serious than old tires."

The Elk River beside West Virginia Route 4.

The clear Elk River meanders down a forested valley and West Virginia 4 curves back and forth alongside it. The *Blue Highways* route followed each curve for forty miles from Sutton to Maysel (*BH* 408).

Elk Lunch, Gassaway, West Virginia, on Route 4.

The columns of the former Farmers and Merchants Bank still provide two-thirds of the signage for the cafe.

It was here that Heat-Moon met a man "whose stomach started at his neck and stopped below his groin" and who knew immediately that Heat-Moon wasn't from around here because he wiped off his beer bottle before he "swigged on it" (*BH* 408).

Suspension footbridge over the Elk River, north of Glendon, West Virginia, on Route 4.

The footbridge, the "emblem of Appalachia," is much less common today than it was in 1978 (*BH* 409).

The Ohio River Bridge, US 35, connecting West Virginia (left) to Ohio (right).

This bridge carried Ghost Dancing back into the Midwest. Only Ohio, Indiana, and Illinois now separated him from Missouri. As he drove through western West Virginia, he knew he was approaching the end of his trip; but he also felt he was driving in another era. "Maybe it was the place or maybe a slow turning in the mind about how a man cannot entirely disconnect from the past. To try to is the American impulse, but to look at the steady continuance of the past is to watch time get emptied of its bluster because time bears down less on the continuum than on the components. To be only a nub in the eternal temporary is still to have a chance to see, a chance to pry at the mystery. What is the blue road anyway but an opportunity to poke at the unseen and a hoping the unseen will poke back?" (*BH* 409).

Dock on the Ohio River, Twin Islands Campground, east of Manchester, Ohio, US 52.

The *Blue Highways* route paralleled the Ohio River for some 150 miles on US 52 from Iron-ton, Ohio, west to Cincinnati (*BH* 410).

Cornfield along Indiana Route 56.

When Heat-Moon passed here in early June, the "corn, tobacco, and blue-sailor grew to the knee" (*BH* 410). When I came through in August 2008, the corn was over my head and the blue-sailor blossoms were gone.

West Baden Springs Hotel, in Indiana on Route 56.

To travel the *Blue Highways* is to find *the unexpected*. For each individual it will be different. The West Baden Springs Hotel is an example—quite unexpected. It's located on one of the bluest of blue highways, Indiana 56, in the mineral springs region of southern Indiana. This 1902 structure replaced the original hotel of 1855, which was destroyed by fire. When Heat-Moon passed nearby, it was a private college, the Northwood Institute.

Memorial Garden, New Harmony, Indiana, on State Route 66.

On his last day of travel, Heat-Moon arrived in New Harmony, Indiana, just twelve miles down the Wabash River from Grayville, Illinois, where he had spent the first night of his journey, eighty-one days earlier.

The town, Harmonie, was founded by German immigrant George Rapp, who headed the Harmony Society (or Rappites), a communal group. On the banks of the Wabash between 1814 and 1824, "they grew wheat, vegetables, grapes, apples, and hops; they produced wine, woolens, tinware, shoes, and whiskey. The Rappite Golden Rose trademark, like the Shaker name, became an assurance of quality." Rapp in 1824, facing growing discontent, sold the town to a Welsh-born social reformer, Robert Owen, and moved his group back to Pennsylvania. "Owen, the British industrialist, utopian, and egalitarian, who worked to create a society free of ignorance and selfishness . . . renamed the town New Harmony and built a cooperative community that developed into a center for creative social and scientific thought in antebellum America." New Harmony has survived, "but only as a monument to idealism and innovation" (*BH* 410–11).

The labyrinth, New Harmony, Indiana.

The labyrinth was originally planted by the Harmonists in 1820. Heat-Moon was stunned to see the similarity of the hedge pattern to the ancient Hopi symbol he saw in Utah (*BH* 185). In an early draft of *Blue Highways*, he finally realized the connection between the Hopi maze and the Harmonist garden. The Hopi maze of emergence—the awakening from the limits of self to something greater—is the key to understanding what *Blue Highways* is about on its deepest level. "The circle almost complete, the truck ran the road like the old horse that knows the way. If the circle had come full turn, I hadn't. I can't say, over the miles, that I had learned what I had wanted to know because I hadn't known what I wanted to know. But I did learn what I didn't know I wanted to know" (*BH* 411).

For a traveler taking to the road, such chances are still out there. An infinity of labyrinths awaits.